60 MINUTES
to Better Painting

SHARPEN your **SKILLS** in oil and acrylic

Craig Nelson

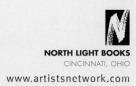

NORTH LIGHT BOOKS
CINCINNATI, OHIO
www.artistsnetwork.com

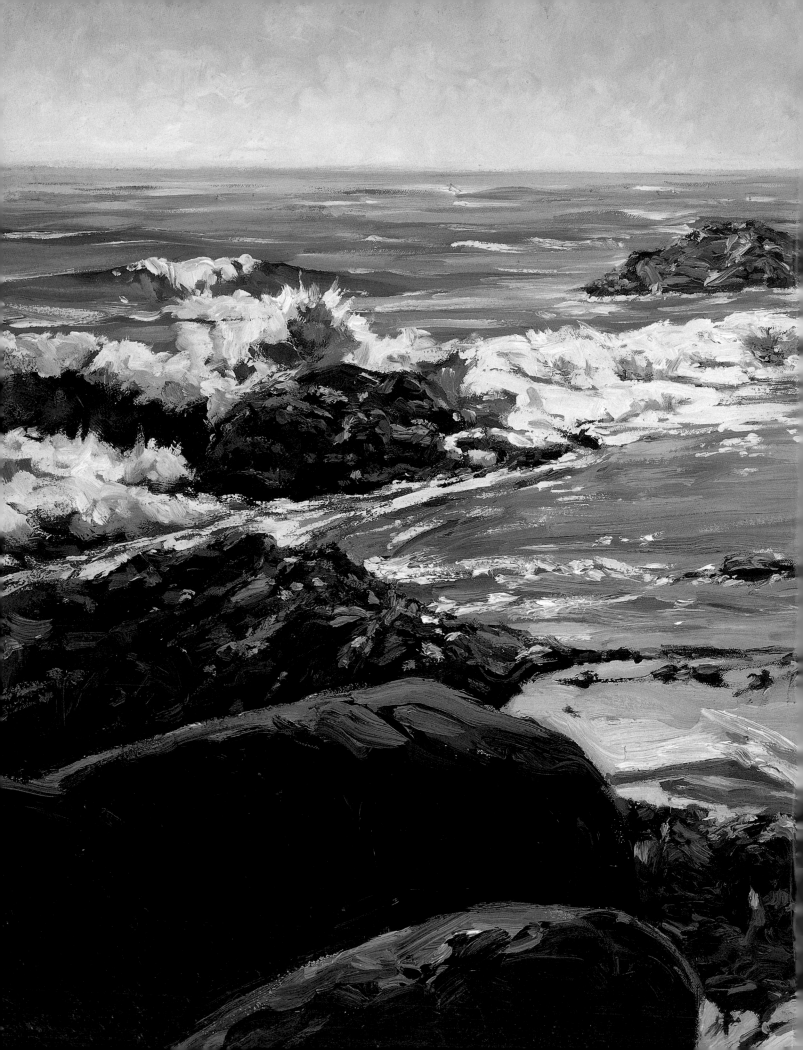

About the Author

Craig Nelson graduated with distinction from the Art Center College of Design in Los Angeles, California, in 1970. He began teaching in 1974 and currently teaches painting and drawing three days a week at the Academy of Art College in San Francisco, where he is Department Director of Fine Art.

His work has appeared on many record album covers for Capitol Records, Sony and MGM. He has also painted many portraits for various stars including Natalie Cole, Neil Diamond, Rick Nelson, Sammy Davis Jr. and Loretta Lynn.

Craig has won over two-hundred awards of excellence in various national shows including being selected for the Arts for the Parks competition for the last eight years. His work can be found in several galleries throughout the United States and continues to appear in exhibitions both nationally and internationally. His paintings also appeared in the book, *Art From the Parks* (North Light Books).

Craig is a member of the Oil Painters of America, the American Society of Portrait Artists and a signature member of the California Art Club. He resides in northern California with his wife and three children.

YOU GO FIRST • OIL • 24" x 36" (61CM x 91CM) • ART FROM PAGES 2–3

60 Minutes to Better Painting. Copyright © 2002 by Craig Nelson. Manufactured in China. All rights reserved. No part of this book may be reproduced in any form or by any electronic or mechanical means including information storage and retrieval systems without permission in writing from the publisher, except by a reviewer who may quote brief passages in a review. Published by North Light Books, an imprint of F+W Publications, Inc., 4700 East Galbraith Road, Cincinnati, Ohio, 45236. First Edition. (800) 289.0963.

06 05 04 03 02 5 4 3 2 1

Library of Congress Cataloging in Publication Data
Nelson, Craig,
 60 minutes to better painting : sharpen your skills in oil and acrylic / Craig Nelson.
 p. cm
 ISBN 1-58180-196-3
 1. Painting—Technique. 2. Acrylic painting—Technique. I. Title Sixty minutes to better painting. II. Title.

ND1473 .N45 2002
751.4'26—dc21 2002025515

Edited by James A. Markle
Designed by Wendy Dunning
Interior layout by Kathy Gardner
Production coordinated by Mark Griffin

Metric Conversion Chart

To convert	to	multiply by
Inches	Centimeters	2.54
Centimeters	Inches	0.4
Feet	Centimeters	30.5
Centimeters	Feet	0.03
Yards	Meters	0.9
Meters	Yards	1.1
Sq. Inches	Sq. Centimeters	6.45
Sq. Centimeters	Sq. Inches	0.16
Sq. Feet	Sq. Meters	0.09
Sq. Meters	Sq. Feet	10.8
Sq. Yards	Sq. Meters	0.8
Sq. Meters	Sq. Yards	1.2
Pounds	Kilograms	0.45
Kilograms	Pounds	2.2
Ounces	Grams	28.4
Grams	Ounces	0.04

Dedication

To my wife, Anna, and to my children, Sasha, Brendan and Ian, who serve as support and constant inspiration.

Acknowledgments

There are many to acknowledge: My mother and father for their constant encouragement and my Aunt Lois, who supplied me with reams of paper as I was growing up. I'd also like to thank Richard and Elisa Stephens and the Academy of Art College for allowing me to develop the quick study concept into a course of study.

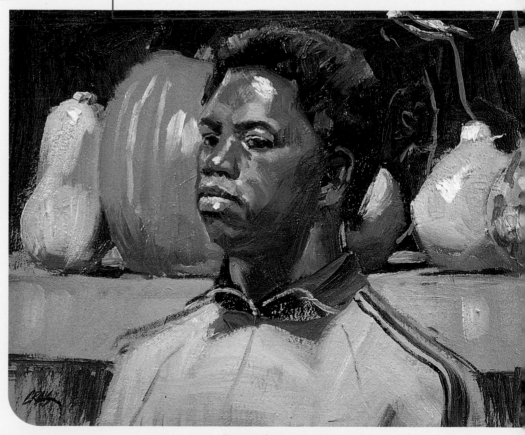

HARVEST PORTRAIT • OIL • 11" x 14" (28CM x 36CM)

Table of Contents

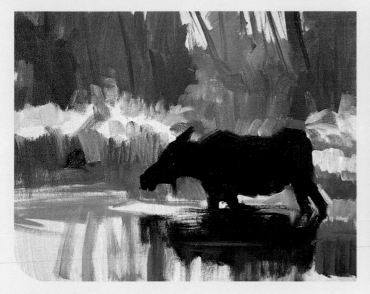

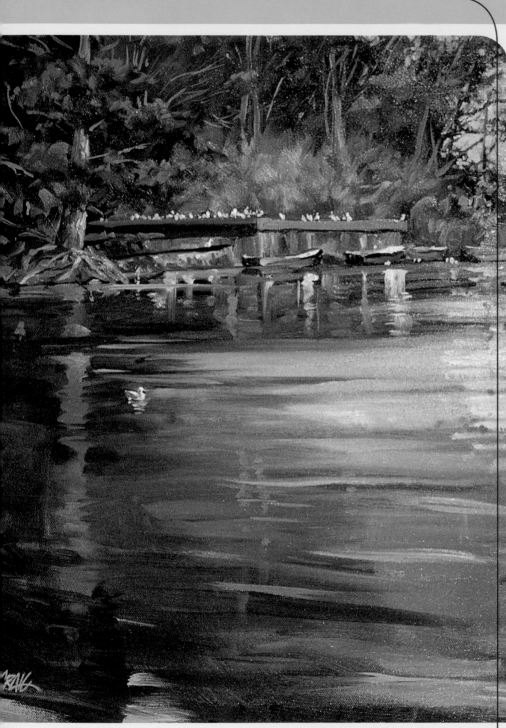

BOATHOUSE FOR THE BIRDS • OIL • 18" x 14" (46CM x 36CM)

Introduction

Painting is sheer joy when it goes right and a great frustration when it doesn't. It is impossible to be a genius every time you set up to paint. When everything is clicking, it is as if your brush is dancing across your canvas depositing dabs and slashes of luscious color exactly where they should be.

The passion of painting is something that we, as artists, experience during the painting process. The magic that happens when we wield the brush with confidence and conviction is what we all strive for. The use of practiced skills combined with insight and individual perceptions makes each of us unique.

All painters want to improve. The novice aspires to be good. The average painter wishes to be advanced, while the advanced and professional measure themselves to selected masters, and so it goes. The common thread is that everyone realizes that they can improve, no matter what their level. The "How to…" is the constant question.

How does one become a better painter? This is perhaps the most commonly asked question by students of all levels. The answer is just paint or *brush mileage*. As simplistic as it sounds, it's the truth. Studying basic principles and methods are helpful, but there is nothing like experiencing the feel of it. Granted, there must be study and careful perception, but the old line "Practice makes perfect" carries a lot of weight here.

Along with practice must come patience. Nothing great happens immediately. Learning and developing one's ability is a slow process, a lifelong pursuit, and one that brings great personal accomplishment and satisfaction.

A common problem that is constantly encountered is the lack of time to paint. Each painting becomes precious and must continually be better than the last, or so one thinks. This can burden the artist to overanalyze and overwork a piece.

Approaching any painting is a mental process followed by technical skills. One without the other is fruitless, like a sentence without punctuation, or a joke without a punch line. A painting that is to be done over several hours or days is automatically considered a finished painting, and therefore carries some preconceived notions and self-inflicted pressure to be right or to be perfect. This will affect the mental approach of most painters, particularly those without years of painting mileage.

After teaching at two most prestigious art schools for the last twenty-six years, I have realized that one avenue of improvement is studies done in short periods of time—*quick studies*. Quick studies allow for no overworking, or overthinking, but utilize basic studied knowledge and begin to bring this to a more intuitive state, much like learning a language.

Quick Studies

By painting quick studies you will:

▶ *Break inhibitions.* Painting is often intimidating. The concept of taking a blank surface and creating a finished, pleasing image on it can be overwhelming. It may paralyze the painter and lead to a tentative approach without confidence.

▶ *Not be afraid of mistakes.* Whenever doing anything, you will make mistakes.

In sports, music or any other endeavor, you must go through some growing pains in order to become proficient or to excel. To be afraid of making mistakes should not keep you from attempting something. That is how we all learn.

▶ *Learn the differences between line and mass.* From our earliest memories we have all drawn with pencil, crayon or pen. Generally, when we draw anything, we start with lines. This, however, is not how we see. We see mass and form; therefore, mass and form is how we must paint. Lines are a shorthand for painting.

▶ *Learn brushwork.* The way in which a painter yields his brush is much of the beauty of a painting. It may be energetic, careful, soft or crisp. It often is like handwriting—very distinctive.

▶ *Understand how to see.* We see images of various kinds. A painter must learn how to see in stages. They must not see the detail first, but must see the larger more basic images before studying the smaller and often more interesting areas. It is important to train your eye to see in the proper order so your subject can be approached as if it were a painting

▶ *Get started.* The evil word, procrastination, is the constant enemy of all painters. That blank canvas and the concept of a finished painting can be a burden. The study, as opposed to a finished painting, can eliminate any burden. It is stated as a study; to learn, to improve, to try something, not a precious final piece of art! When procrastinating on what to do, how big, etc., do a study.

▶ *Learn, explore and enjoy!*

Basic Time Frames

In order to help simplify the time you may work on a study, I recommend three basic time frames. Although only 15 minutes in difference, they allow different degrees of finish and enable you to use your brushes for different effects. These short time frames will help with pacing a painting. Subject matter may dictate the time frame you wish to work within. For example, when painting on location, you may wish to give yourself 45 to 60 minutes on a study. A head or a simple still life may work better within a 25- to 45-minute time frame. I recommend that you use a timer and keep a constant eye on it. If you are working with a model, it is easy to know when time is up. He or she may just stand up and walk away. A still life or landscape takes more discipline to work within your given time frame. Remember it is a study. Be bold and keep pacing yourself; finish it and move on to another.

25–30 minutes: This abbreviated form of painting truly helps with decision making. In order to truly capture the essence of your given subject, this time frame will not allow you to overthink anything. It is ideal for 8" × 10" (20cm × 25cm) or smaller, although a 9" × 12" (23cm × 30cm) may work as well.

40–45 minute: The addition of only 15 minutes after doing three or four shorter studies seems as if you suddenly have a lot more time. It is important to keep up the quick pace and utilize the additional time for refinements, and a bit more thought.

60 minutes: The one hour study allows for a more finished looking study. It still requires an abbreviated approach but it gives a bit more time for decisions, development of color, form or detail.

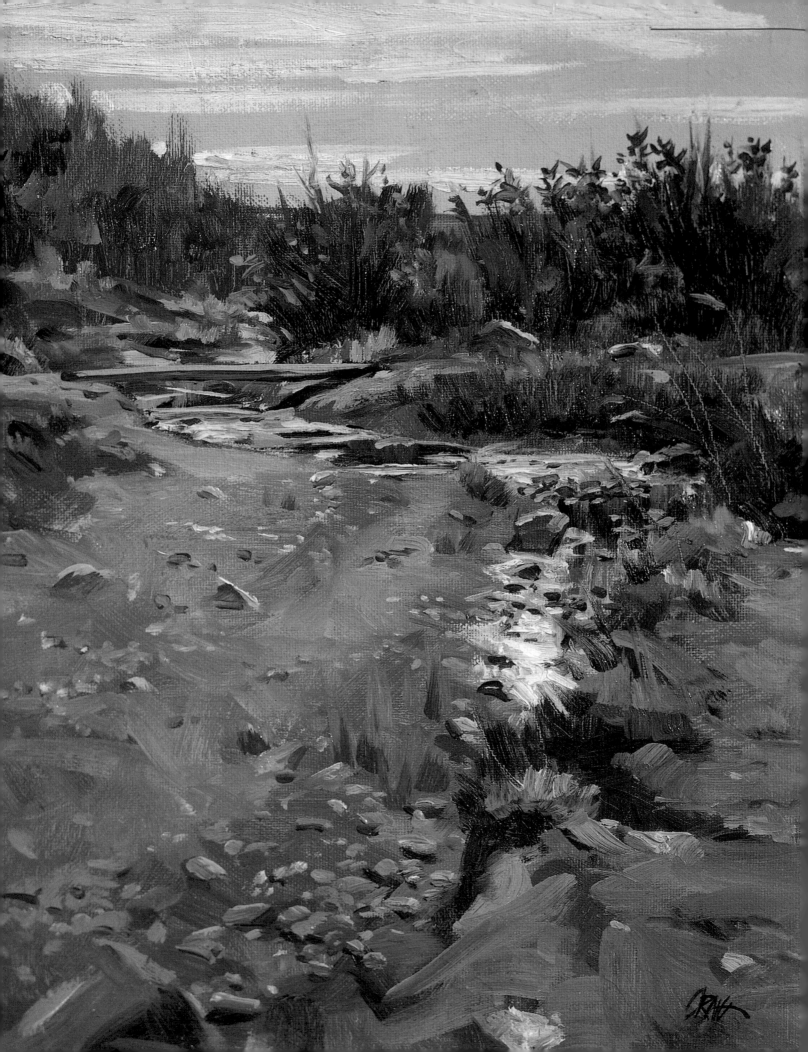

Why Do Quick Paintings?

There are many legitimate reasons for doing quick paintings or studies. In addition to improving your general painting ability, some of the benefits you will receive are: better editing skills, increased brush confidence, exploration of new subjects, new compositional variations, greater color exploration, awareness of various lighting effects, compositional practice before larger paintings, increased basic practice and, last but not least, recreation or fun!

Select Subject With Various Textures and Edges
At Muir Beach there was part of a creek that was dried up with stones, weeds and a board that someone had bridged across it. For some reason the view struck me. I realize now it was the variety of textures and edges that challenged me. I limited myself to a 60-minute study and could have easily spent a lot longer painting it, but I wanted this to be a study and not a finished painting.

END OF THE CREEK • OIL • 60 MINUTES • 14" x 11" (36CM x 28CM)

Editing

A painting limited to 25 to 60 minutes will force the painter to make important decisions quickly. This shorter time frame alters the finished mental approach to painting, and gives way to a more abbreviated mental approach. It makes your paintings more relaxed and fluid. Suddenly the responsibility of being perfect or finished is relieved.

Instead the painter must decide what is important and what is not. This leads to rapid decision making and editing the subject matter down to its essence. What conveys the essence of the subject? Is it shape? Simplicity? Complexity? Form? Edge? Value contrast? Color? Or something else?

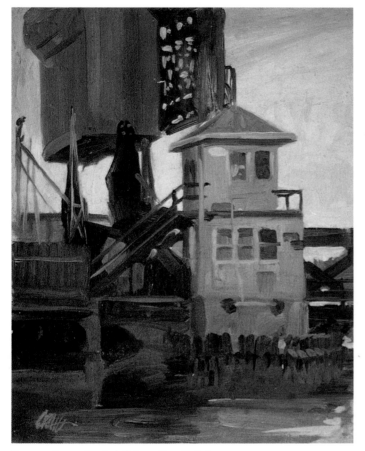

Remove Excessive Detail From Your Paintings
This location study was done on an overcast day, so I painted simple warm and cool neutral grays concentrating on simple value variations and geometric shapes. I used some yellow in the sky to give a little snap to the study. Notice, only the bridge house has any semblance of detail.

CHINA BASIN BRIDGE • OIL • 45 MINUTES • 10" x 8" (25CM x 20CM)

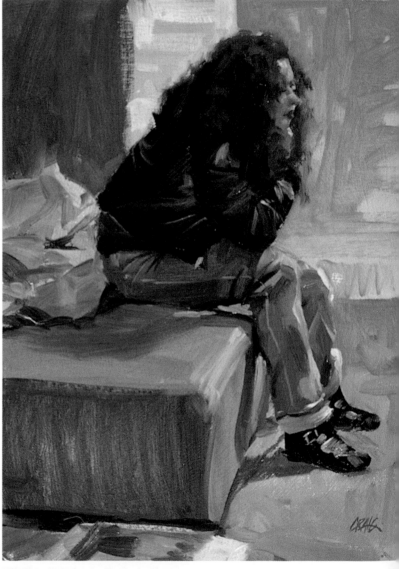

Edit Your Painting to its Basic Shapes
This study from a model consists primarily of shapes. Granted, proportion and gesture are important, but it is the simple shapes that carry the bulk of this picture. The edge of the hair is important, but the only modeling is in the face, pants and a touch or two in the jacket.

BLACK JACKET • OIL • 25 MINUTES • 16" x 12" (41CM x 30CM)

Brush Confidence

Building brush confidence comes with mileage. The quick-study approach will help you develop confidence in your brush handling. The shorter time frames will influence your brushmanship. Your brush must do more with less. The load of paint, it's consistency, the pressure of the stroke, the application, the release of the stroke, the facet of the brush you use are all considerations with each and every stroke. These quicker paintings will force those quick decisions so that after time they will become more or less instinctive. Mileage is still the answer, but it's done more rapidly through the practice of quick studies.

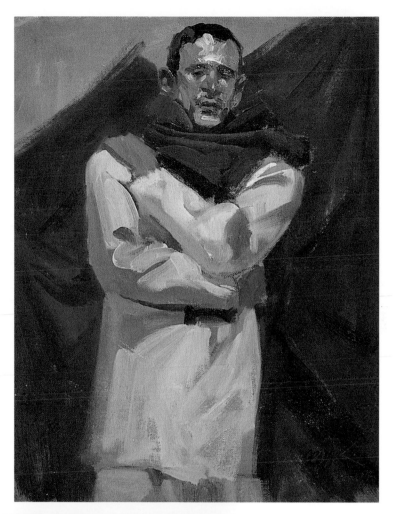

Use Brushwork to Create Form and Accents
This is rather large for a study, but I wanted to work with large brushes. The majority of this is done with nos. 10 and 12 hog bristle filberts. Some bold strokes and thick paint are used at the very end with a no. 8 to give additional form and accent to the face.

BIG PURPLE SCARF • OIL • 30 MINUTES • 18" x 14" (46CM x 36CM)

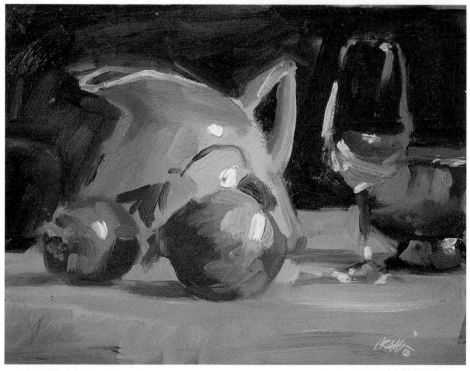

Brushwork Creates Interest in Simple Shapes
This study was painted from background to front using nos. 8 and 10 hog bristle filberts. I basically concentrated on the large simple surfaces overlapping bold strokes and painting the closest objects last.

ONIONS AND THE PATTERNED PITCHER • OIL • 30 MINUTES • 8" x 10" (20CM x 25CM)

Exploring Various Subjects

An exploration of different types of subject matter is a wonderful motive for attempting paintings of shorter time periods. Most painters select subjects to paint because of interest or familiarity. A painter living in the mountains may paint mountains, while one living by the sea may be more prone to paint seascapes. Painters who love color and still lifes may be more inclined to paint flowers.

Many painters have a fear of attempting the unfamiliar subject, or a subject that upon first glance may appear mundane or uninteresting. The investment of time to produce most paintings may keep an artist from attempting new subjects, for fear that it will not make an appealing painting. Artists such as Rembrandt painted a hanging side of beef, John Singer Sargent painted the reflections in the corner of a pond. Vincent van Gogh painted a group of old shoes. Although these artists were known for other artistic accomplishments, they all explored various other subjects.

A painting done quickly allows a painter the luxury of exploring various subjects without the fear of the lost investment of time. This enables a painter to discover new properties of painting they had never dealt with. It may even inspire a new series of paintings.

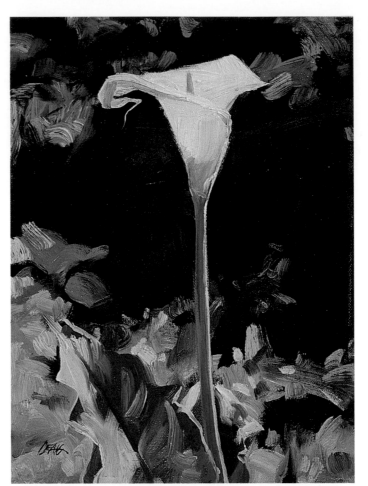

Select Intimate Subjects
During an outing at Muir Beach, I decided to pick a more intimate subject. This study was painted in the early afternoon and dealt with a singular element, a concept I usually shy away from. What attracted me to this new subject was the abstraction and chaos of the leaves punctuated by the cleanliness and grace of the lily.

SOLO • OIL • 45 MINUTES • 12" X 9" (30CM X 23CM)

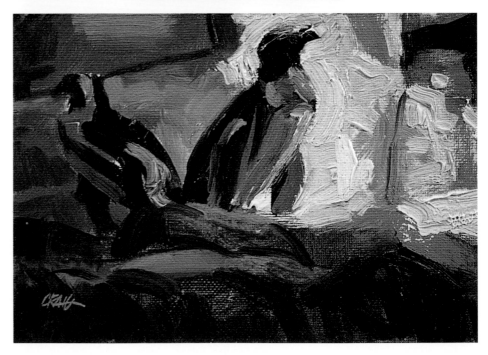

Choose Subjects That Challenge You
I visited the San Francisco Aquarium and went immediately to the penguins. I shot several photos with the idea of doing paintings. One afternoon in class I was doing a series of 25-minute demonstration studies and chose the penguins because it took some color invention. The defining shapes of the animals were intriguing with little light on them.

FORMAL DUO • OIL • 25 MINUTES • 5" X 7" (13CM X 18CM)

Exploring Composition

If you wish to paint a flower or an apple, generally you will paint it in the middle of the page. This is not necessarily bad, if you are only working on the form or color. Usually after gaining some painting experience, you will realize that the overall design of a painting plays an important role in its impact. It is at this point that you have discovered the importance of composition. Just like subject matter, a variety of compositions need to be explored. This includes subject placement, overlapping of elements, cropping, and use of negative space.

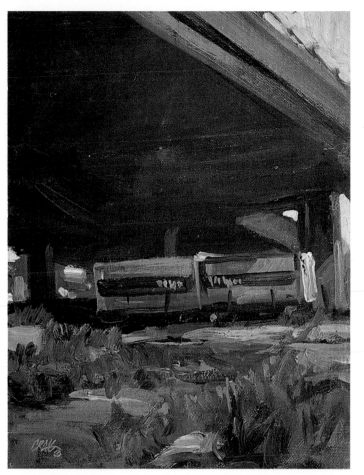

Use Unusual Shapes and Cropping to Create Interest
The huge looming structure of the old I-280 freeway was a great simple shape to play off the abstract ground weeds and the clear structure of the two trailers. This composition is based on huge geometric shapes, ground abstraction and rectangular structure. The cropping and arrangement of elements intrigued me. Unfortunately while I was painting, a truck pulled up and drove the trailers away, so some of it was completed from memory.

Beneath the Old 280 •
Oil • 25 minutes •
12" x 9" (30cm x 23cm)

Balance Your Composition
This study illustrates the concept of using the center of the painting as non-subject matter. For this, the shadow served as a unifying factor, instead of having a hole in the middle. The light switch at the right was included to help break up the upper portion of the negative space and bring some balance to the otherwise unbalanced composition.

The Tell Tale Shadow • Oil • 30 minutes •
11" x 14" (28cm x 36cm)

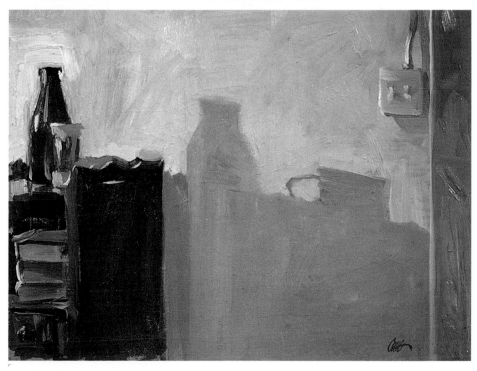

Exploring Color

Color is to painting what spices are to cooking. Without accurate color usage, a painting will be bland; tasteful color adds vitality. Working towards great color is a lifelong pursuit, and is one of the great joys of painting. There never seems to be enough time to explore different color palettes; however, studies are excellent for color exploration. Color may be the primary concern in a quick study. You may wish to exaggerate or mute color intensities, work towards a particular analogous color palette, or use a limited color palette.

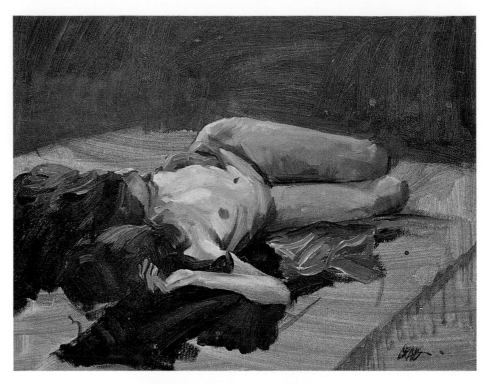

Local Color, Light and Shadow Influence Color
I used a low light from the left to keep most of the figure in shadow. I often use the nude to explore color variations in the seemingly monochromatic fleshtones. I had to keep in mind that two factors influenced the color. First, the local color in the flesh changes due to physiology and second, how the warm light and cool shadow light affected the body.

RESTFUL • OIL • 40 MINUTES • 14" x 18" (36CM x 46CM)

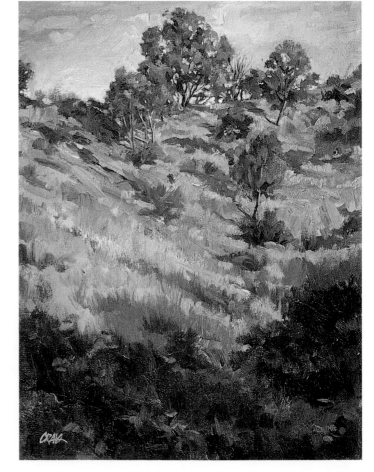

Analogous Color Scheme
This study was completed in about one hour in Griffith Park in Los Angeles. The color is what grabbed me. It was about seven o'clock one August evening and the late light gave a golden analogous glow to the hillside. As I painted, the light changed quickly adding in a foreground shadow. I added this shadow in at the bottom as an anchor for the composition.

AUGUST LIGHT • OIL • 60 MINUTES • 16" x 12" (41CM x 30CM)

Exploring Various Lighting Effects

People often respond to the mood of a painting. This may be influenced by a color feeling, but is more often a result of a lighting effect. In landscapes, time of day or weather conditions will affect the condition of light. In still lifes or figurative work, it may be the direction or angle of the light source, or even multiple light sources, or possibly the distance of the light. Is the light warm or cool? Why and from where is it coming? Do not rely on one safe lighting format, try different lighting effects and see what you can create.

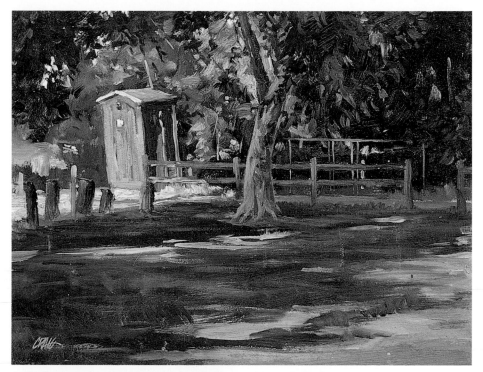

Light and Shadow

In landscape painting you are dealing with nature; the morning and evening light gives the most dramatic effects. In this case, it was about six-thirty in the evening and the late sun was filtering through the foreground trees to light the background and the building. Looking past a shadow to the light is always intriguing. In this case, the dappled light added a nice atmospheric touch.

BEYOND THE SHADE • OIL • 60 MINUTES • 12" x 16" (30CM x 41CM)

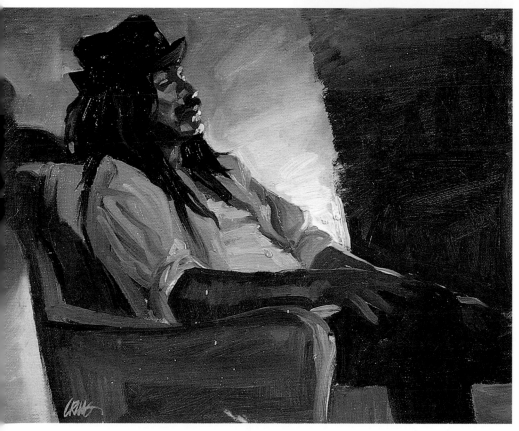

Lighting From Below and Behind

Light from below can be a lot of fun; you must reverse your traditional thinking in the way that light usually comes from above. I kept the light low (on the floor) and from behind, lighting the background more than the model. The key to the painting was to unify all of the shadows, which I painted first. I used a relatively cool influence and finished with the snappy warm light accents coming from below and behind.

OTIENOS COOL HAT • OIL • 40 MINUTES • 11" x 14" (28CM x 36CM)

Trial Before a Larger Finished Painting

Almost all painters have used studies as a quick indication of what they might want their larger finished pieces to look like. The study shows your first concept of the image on canvas. And it is in the study that you may realize that you wish to change something to see if it works to your satisfaction before proceeding to the more time-consuming finished painting. You may wish to try a couple of viewpoints, subtract or move something, or decide if it is worthy of doing a completed version.

Many times I have thought I might do a large painting of something only to find in the study that I don't believe it would work well large.

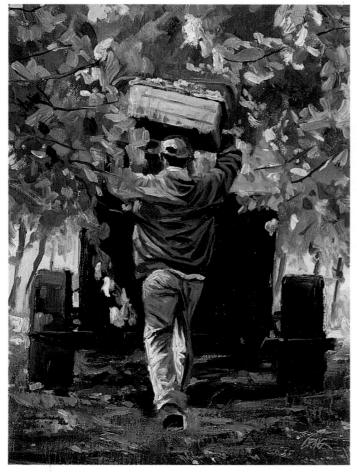

Studies Provide the Basis for Larger Work

Living in the California wine country, several subject matters have caught my interest. I have had the good fortune to be invited onto the grounds during harvest time and have painted many vineyards. Rolling on the ground, and climbing under grapevines, I have shot many photos of the workers harvesting. These photographs have been the inspiration for many studies and larger finished paintings. The colorful abstraction of the grape leaves are a wonderful setting for a figure. Like a great dance performance, they move swiftly and with the utmost efficiency. It has been a joy to paint the many studies, and extremely exciting to attempt to convey all of this in a larger work.

TOP LOAD STUDY • OIL • 55 MINUTES • 14" x 11" (36CM x 28CM)

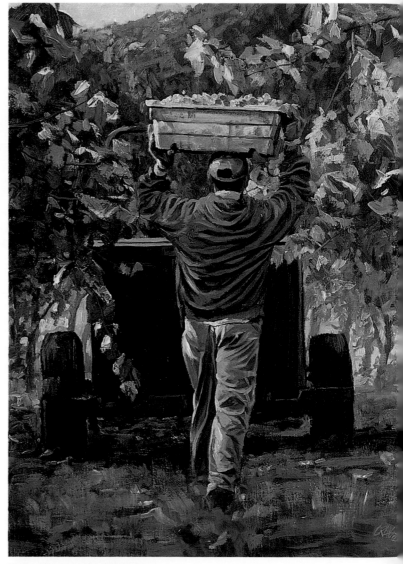

Refine Your Finished Paintings

I wanted to keep the basic color and attitude of the study but uncover the figure so that both hands showed gripping the large bin. Also I decided to show both feet to give him a more secure base. Other than this, it was a matter of developing a richer and more layered look in the grapevines, and carrying the refinement further.

TOP LOAD • OIL • 12 HOURS • 24" x 18" (61CM x 46CM)

Basic Practice

The fine craft of painting is akin to the fine craft of playing music. Musicians must constantly practice, playing scales and difficult passages to improve their skill level and to keep them sharp. A basketball player may shoot two- or three-hundred shots a day for the sake of practice. The world's top opera singers still perform vocal exercises daily. A track star is hitting the weight room, running distances, sprints and so on. Tennis players work to improve their serves and volleys. Golfers constantly work on their drives and putts to improve their skills.

Painters need to do the same thing. The old saying, "Practice makes perfect," carries a lot of weight. As a trumpet player must practice his chops, a painter must work to develop his or her art of seeing. They must practice their chops, or in this case brushmanship, their general sensitivity towards their medium and their subjects. This gives growth and depth to the painter, not to mention confidence.

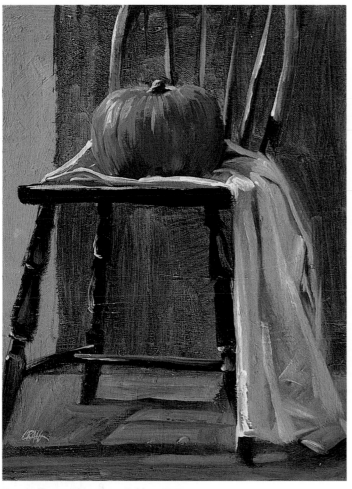

Use Ordinary Objects as Subject Matter
During October and November we usually have pumpkins around. They are fun colorful subjects with clear form and wonderful subtleties. For practice I set this pumpkin in a chair and added a cloth to give three different and distinctive forms in one picture.

A COMFORTABLE PUMPKIN • OIL • 40 MINUTES • 16" x 12" (41CM x 30CM)

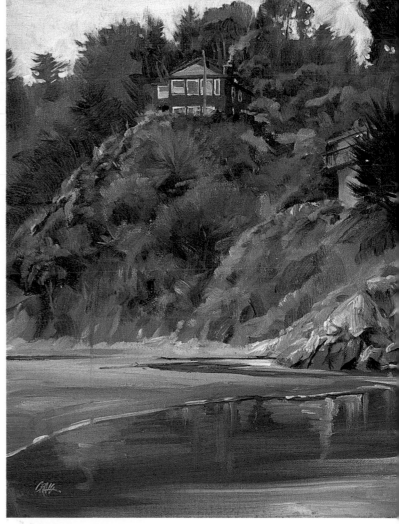

Find Beauty on a Gray Day
I constantly practice on gray days as it allows me to see forms and textures without the dominance of sunlight. As in the pumpkin painting, it was the textural and surface variety that challenged me. Weeds, rocks, trees, architecture, water and reflections are a rich tapestry for a study or a finished painting.

SOMEONE'S AT HOME • OIL • 60 MINUTES • 18" x 14" (46CM x 36CM)

Recreation: How, Where and When?

At some point it is important to remember why you paint. I had a student walk out of class exhausted and state, "This is fun." The main reason all of us begin painting is because we enjoy it. There is a joy in painting, a high that is indescribable. This is easily forgotten during those frustrating periods when seemingly nothing goes right. Frustration is an unfortunate product of yearning to be better. This is difficult, but you must learn to work through it.

Painting is my vocation as well as my avocation. I paint as a profession and I paint on vacation. It is great to join an art group and go out together to paint, learn, grow and enjoy each other's company. The quick study takes the pressure off and it is then possible to rediscover the fun and sheer enjoyment of painting.

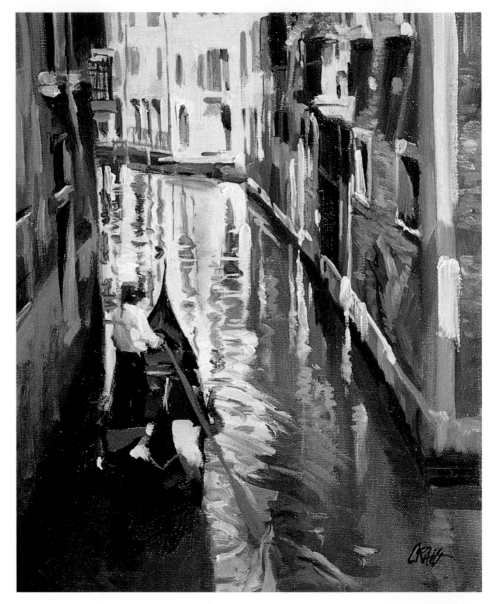

Paint While Traveling Abroad

Italy without a paint box would be a crime for me. Venice is one of those places you can just put yourself down anywhere to paint and you will have instant inspiration. I particularly like the quiet out-of-the-way canals; if you are lucky, a gondola might pass by. This guy actually stopped and rested for about five minutes before continuing on his way.

QUIET PASSAGE • OIL • 60 MINUTES • 14" x 11" (36CM x 28CM)

Paint in the Solitude of Morning

My family generally takes a vacation every summer. Cabo San Lucas at the tip of Baja California is one of our favorite places. The rock formations at land's end is inspiring. I always take along a Pochade box for fun. One morning as everyone slept, I went out on our balcony with a mug of steaming coffee and did this study. As a boat passed by, I thought it gave a nice exclamation point to the rugged organic rocks.

CABO SAIL • OIL • 45 MINUTES • 8" x 10" (20CM x 25CM)

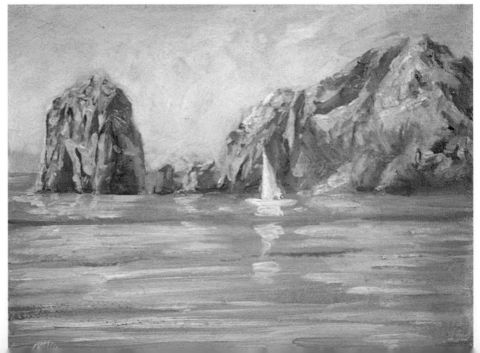

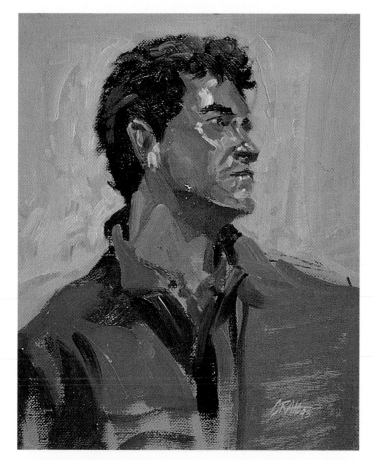

It is obvious that practice is the way to grow and improve. In these quick studies it is possible for you to take 30 to 60 minutes, without the pressure of producing a precious finished piece, to attempt to complete a small study of whatever you wish to paint.

Take a can full of brushes, a couple of onions, a couple of books and a coffee cup, a flower from your garden, or a photo you may have shot on vacation. The point is that it doesn't have to be an overwhelming subject. In fact, for the sake of practice, it is better that it is something that you do not have too much of an emotional attachment to. That will only influence you to be too perfect and destroy the concept of a study. The pressure of not doing a finished painting is the best part of this learning experience. Remember this is an exercise, but it just might turn out to be a great little piece of art.

Practice, Practice, Practice
I love to practice painting heads. This was a 30-minute demonstration from a model for a workshop. He has great facial structure and the bit of red shirt under the jacket was a nice color note.

DAVID • OIL • 30 MINUTES • 10" x 8" (25CM x 20CM)

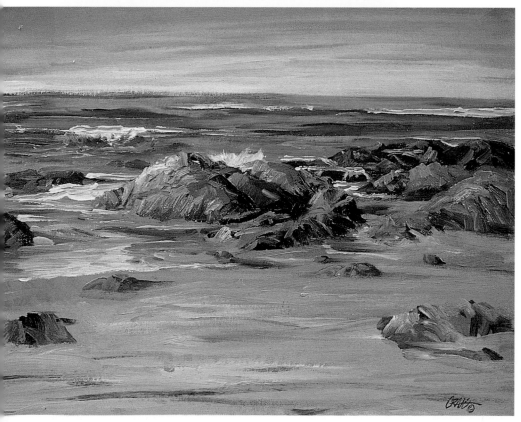

Painting on the Beach, What Could be Better?
The crisp ocean weather, the smell of salty air, the soothing sound of the surf; it makes me want to capture it all. *Surf on the Rocks* was painted in the afternoon on the Monterey Peninsula. Here I captured the action of the surf as it meets the rocky shore.

SURF ON THE ROCKS • OIL • 60 MINUTES • 14" x 18" (36CM x46CM)

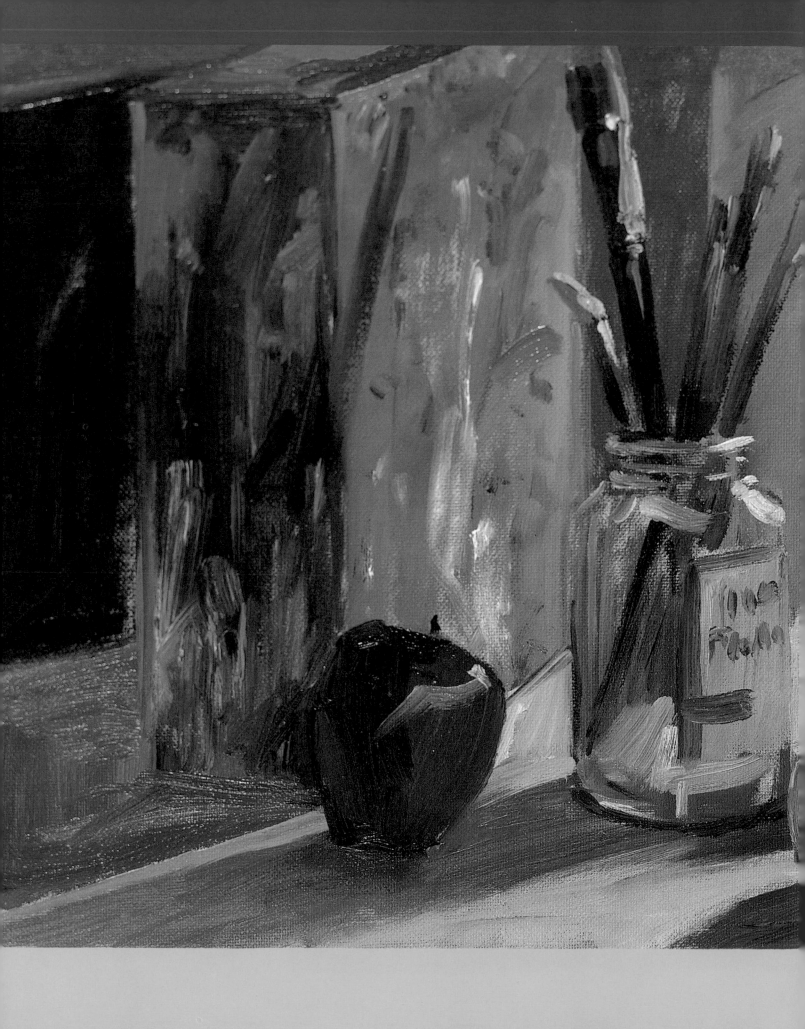

The Quick Painting Process

In order to produce quality work consistently, it is extremely important for each painter to thoroughly understand his or her process or procedure from beginning to finish. Every painting goes through various stages towards its completion. Each stage must build upon the previous one. As in a finished, more refined painting, a quick study will go through the same stages, only in a more abbreviated manner.

Paint What You Have
Many times a casual arrangement of the objects found in the home or studio serve as great subjects to paint.

ART SUPPLIES • OIL • 40 MINUTES • 11" x 14" (28CM x 36CM)

Supplies

Paints

You will find as many opinions about paints, brands and colors as there are painters. Make sure you purchase professional quality, not student grade, paints. A strong palette is vital for any painter. I generally recommend this palette for both oils and acrylics.

Alizarin Crimson

Burnt Umber

Cadmium Red Light

Cadmium Yellow Light

Cerulean Blue or Winsor Blue

Sap Green (Hooker's Green for acrylics)

Terra Rosa (Red Oxide for acrylics)

Titanium White (a soft formula for oils, Gesso for acrylics)

Ultramarine Blue

Viridian

Yellow Ochre

Brushes

You must purchase good brushes. Often I find the root of a problem is a poor brush. It is impossible to paint a successful painting with poor brushes. Take good care of them, keep them clean and wash them out with brush soap after each use.

Nos. 1, 2, 4, 6, 8, 10 and 12 hog bristle filberts

Nos. 4, 6, 8, 10 and 12 hog bristle flats

Sable flat for oils

A large 2- to 3-inch (51mm to 76mm) flat for acrylics

Mediums

Oils Again, mediums are open to varied opinions. After trying a wide variety, I have settled on odorless, or non-toxic, turpentine as a solvent. As a painting medium, I use Liquin. For my finish coat, I use $\frac{1}{3}$ damar varnish, $\frac{1}{3}$ linseed oil and $\frac{1}{3}$ turpentine.

Acrylics I thin with ordinary water when working with acrylics.

Palette

There are many types of palettes for you to choose from. Be sure the palette you select is compatible with the type of paint you use.

Oils I prefer a piece of glass approximately 14" × 18" (36cm × 46cm), duct taped around the edges over a medium gray painted piece of Masonite for my palette.

Acrylics I use an enamel butcher tray approximately 14" × 18" (36cm × 46cm).

Travel Palettes French easels and Pochade boxes come with their own wooden palettes.

Containers

You will need the right container for the right job.

Oils An inexpensive jar with a lid made from silicon works well. There are many more expensive turpentine containers available if you want to spend the money.

Acrylics A good size plastic water bucket works great.

Rags

Do not use paper towels; basically they're just too messy. Old cotton T-shirts, old towels or shop rags work best.

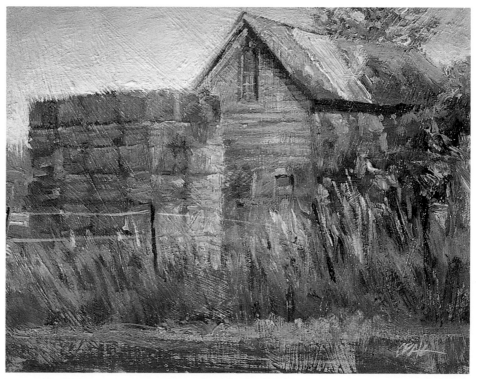

Healdsburg Haystacks • Oil • 30 minutes • 8" x 10" (20cm x 25cm)

Timer

For the sake of pacing, a timer is essential.

Easels/Pochade Boxes

The workhorse for many artists is the French easel or field easel (full or half). This can be transported easily or used in your studio. I often refer to this as a "studio in a box," as it holds the easel, paints, palette and a canvas. Various Pochade boxes are available, all of which work fine. However, most Pochade boxes come without legs so buy one with an attachment for a tripod.

Grounds and Surfaces

Try various grounds and surfaces. You may discover one that suits you better than another. Canvas on stretcher strips and canvas panels are obvious choices. Gessoed Masonite, gessoed hardboard and gessoed illustration board are other good options. Each ground/surface combination responds differently to the brush so experiment until you find one that suits you. I highly recommend working on a toned surface as this often relieves the anxiety of covering the white of the canvas.

Setting

How you organize your art materials and working space depends on whether you are in your home studio or on location.

Home Studio A French easel will work great in a studio or on location. However, a standard easel (one that is more stable) is desirable. A taboret is necessary to hold your brushes and palette. There are many fancy brands, all very fine, but a basic small table, approximately 30 inches to 36 inches (76cm to 91cm) high, will work great.

Location On location (painting *en plein air*) compact and lightweight is the best plan. The French easel or Pochade box works best for working outdoors. You may wish to purchase a lightweight collapsible stool and, possibly, a white clamp-on umbrella to shade your painting from direct sunlight. Also be sure to protect your skin from the sun with protective clothing and sunblock.

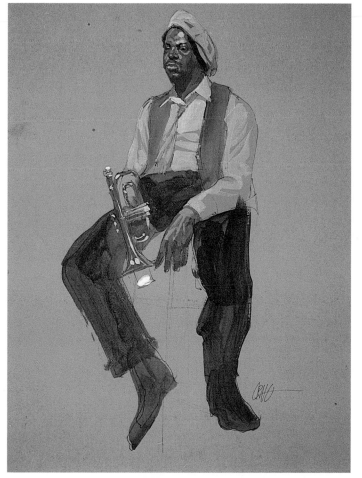

Bob's Horn • Acrylic • 25 minutes • 20" x 16" (51cm x 41cm)

Palette Layout

I have seen artists lay out their palettes in many configurations. I personally use the *spectrum* layout, however I have also shown two other popular layouts, the *warm-cool* layout, and the *chroma-earthtone* layout. The important thing is to be consistent. Your palette layout is like a piano keyboard. It should be the same each time you use it.

When laying out an acrylic palette, squeeze your paints on a folded strip of wet paper towel. This will help keep them moist and prevent your paints from drying out.

Spectrum
The colors in this palette are laid out to replicate the spectrum, or rainbow.

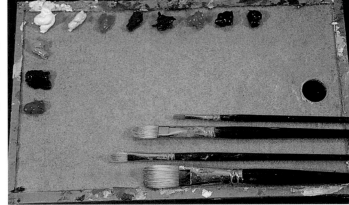

Chroma-Earthtone
You may choose to organize your colors into two groups: chroma, which would be yellows, reds and blues, and earth tones, which are browns.

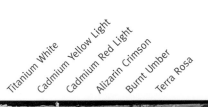
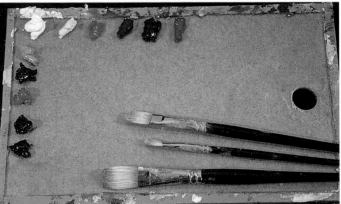

Warm-Cool
You may opt to arrange your colors according to temperature. The cool colors are placed on the left side of the palette. The warm colors are placed along the top.

Setup

Painting in your studio or home is very different from painting outdoors or on location. You will have different needs and tools when painting on location. It is also important to travel light and prepare for any situation you may encounter.

In the Studio

Your studio is where you paint while indoors. It may be a separate building, a room in your home or a given area in your room. Whichever it is, it should be well lit. Light coming from the north is the most ideal form of light. This is great for daytime, but if you work evenings or late at night you need a good form of artificial lighting. The new natural lightbulbs are the best form of artificial light. Another good form of artificial lighting is an architect's lamp, which contains both warm and cool light to give a reasonable balance. Do not underestimate the importance of working under good lighting.

An easel and taboret are other necessities as discussed earlier. Along with these, a light for lighting subjects is also necessary. The most ideal lamp is a tripod light stand and a reflector to house the bulb. Some beginners purchase an inexpensive clamp-on reflector that will work.

A small table, preferably set against a wall, for setting up still lifes is also desirable. Props may be anything you have around as you'll see later. If you paint from models, a comfortable chair or sofa will go a long way toward keeping your model happy.

On Location

Painting on location or *en plein air* requires a bit less than setting up a permanent home studio. As mentioned on page 25, the French easel or Pochade box is the best equipment for location painting. You may also wish to bring a collapsible camping stool. Some painters prefer to sit on the ground. If this is the case, bring along a pillow to sit on.

When setting up on location, it is important to pick a spot where you can do more than one study without moving. For example, one study may be a more intimate or close up subject, one may be more distant or panoramic, and one could be more to the left or right. If you don't have a clamp-on umbrella, be sure not to set up with sunlight on your canvas. Keep it to the left or right of the subject, not on your canvas.

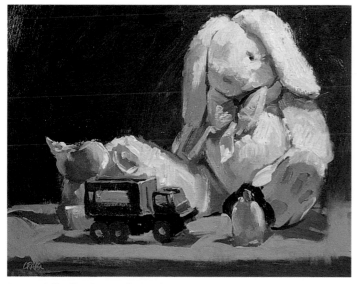

Create Still Lifes for Studio Work
Still life setups are great in the studio. I raided my children's stuffed animals and old toys for this study. It was lit by a single light source from a 40-degree angle from the right.

BUNNY'S STUFF • OIL • 40 MINUTES • 12" x 16" (30CM x 41CM)

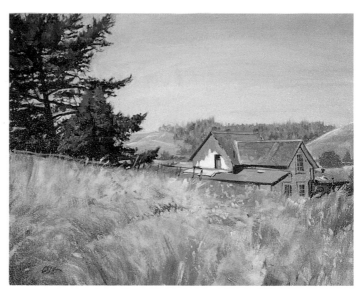

Find Local Vistas for Location Work
This was an ambitious 60-minute study done about twenty miles from my studio. The trees are basically simple shapes and the foreground brush is simplified strokes. The majority of time was spent on the architecture, and going back to the negative spaces in the trees and their edges.

HOUSE OVER THE HILL • OIL • 60 MINUTES • 14" x 18" (36 x 46CM)

Sketching

When we first make marks with a pencil or crayon, we are basically sketching. A sketch generally depicts its subject in a linear fashion dealing primarily with the contour and basic linear breakdown of a given subject. At times a sketch may incorporate a bit of tone achieved by linear hatching, scribbling or smudging.

Sketches may convey accuracy in perspective, proportion, gesture, and composi-tional intent. It is often the groundwork on which a more finished piece is based.

Finished paintings often have a strong sketch underneath as a preliminary plan. Most painters begin their painting with a sketch of one form or another. It is with this premise that the sketch-and-paint approach to a quick study is often used.

When sketching for a quick study, the important information to get down is com-position, subject placement, basic shapes, perspective (if necessary), proportions and gesture (if necessary). It is important to understand that the purpose of the sketch is to create a shorthand or rough skeleton for the painter to build on. However, too finished of a sketch may inhibit one from painting boldly and directly. About 2 to 5 minutes should be long enough for any sketch before painting a quick study.

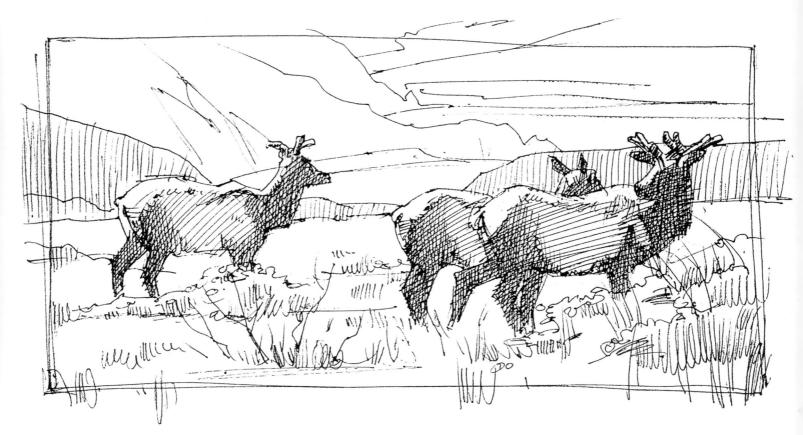

Pen Sketch
This is generally thought of as a sketch—an image dealing primarily with contours, shapes and a minimum of tonal hatching. Although not thoroughly finished, it conveys the basic information.

TULE ELK • PEN • 5 MINUTES • 4" x 7" (10CM x 18CM)

Sketching and Painting Organic Forms

Sketching and painting organic forms like the figure takes a slightly different approach. Look for contours, angles and lengths to help turn the basic shapes into a recognizable figure.

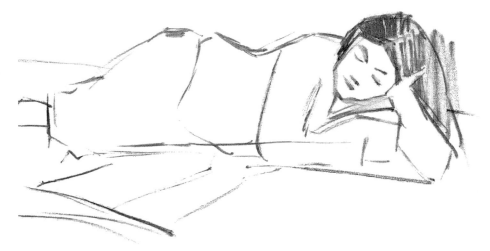

Sketch of *Girl at Rest*

Notice the up and down contour of the top of the figure and the relatively straight or flat quality of the figure resting on the ground. When sketching, it is best to look for angles and lengths. Angles will give gesture and lengths will give proportion. These will, in turn, create the basic shapes of the subject. A basic sketch in this situation should take about 2 or 3 minutes using a no. 2 bristle filbert.

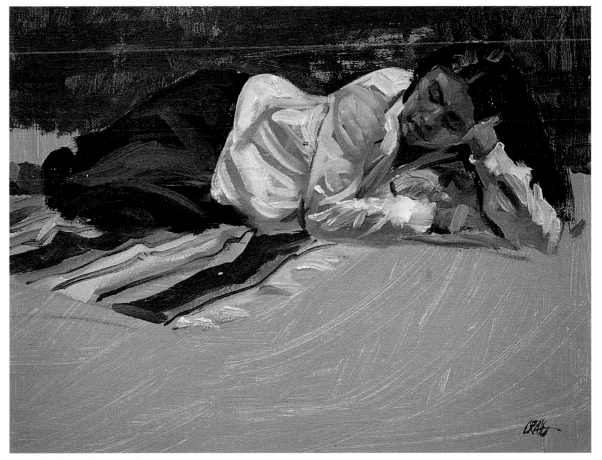

Quick Study of *Girl at Rest*

I used the rough sketch as a guideline for this study. The background tone at the top helps to establish the figure contour. I created the dark shapes of the hair and skirt before moving on to the blouse and face. The basic premise is to create masses where there are lines. Finish by adding light and shadow to give form to the masses.

GIRL AT REST • OIL • 40 MINUTES • 11" x 14" (28CM x 36CM)

Sketching and Painting Geometric Forms

Sketching architecture requires a more geometric approach than figurative subjects. Straight horizontal, vertical and angular lines work best. Proportion and perspective play an important role in most architectural subjects.

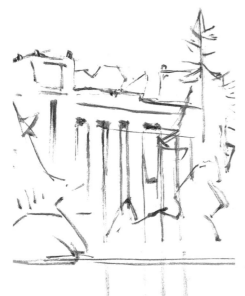

Sketch of *Palace in Shadow*
Some complex architecture can be overwhelming. It is important to break it down to its basic shapes. This subject has a strong vertical thrust. The columns and the trees have a repetitious upward movement. It is, therefore, important to get the approximate placement of the columns and the slight angle of the roofline to give the subtle perspective. As for the trees, it is the larger masses and the basic rhythm of the branches that need a quick indication. This sketch should take no longer than 3 or 4 minutes.

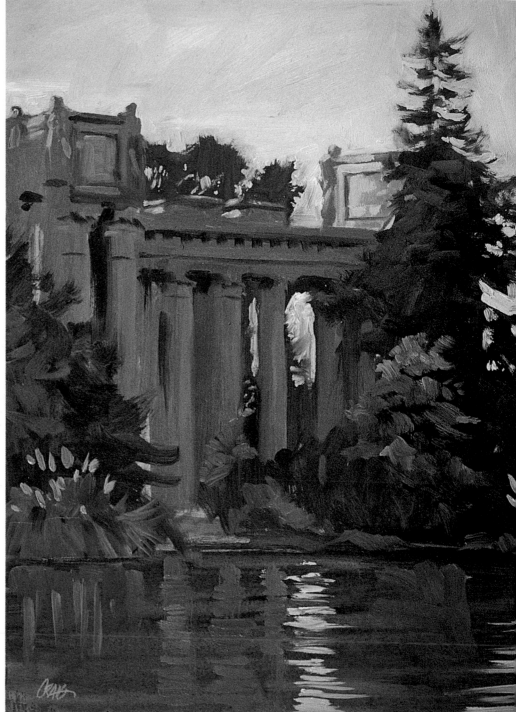

Quick Study of *Palace in Shadow*
Before painting this study, notice the differences in edge qualities between the architecture that has firm, crisp edges and the tree forms with wispy, soft edges. I laid in a very light blue-gray sky for the background using a no. 10 brush; then I moved on to the background trees. The architecture is a basic grayed brown (in shadow) that should be simplified using a no. 8 bristle flat. All elements should be painted in their basic shapes, with attention to the edges. This transforms the basic linear sketch into masses, which is how we see. Form can then be developed with value and color variation.

PALACE IN SHADOW • OIL • 40 MINUTES • 12" x 9" (30CM x 23CM)

The Two-Value Statement Technique

In most lighting conditions any given subject may be depicted in a simple two-value statement. That is to say, each element in a picture can easily be broken down into two basic values, a light and a dark. This is a very important stage in every study or every finished painting. It is, in fact, this two-value statement that is what all of the subtleties, color nuances and detail will be built into. Therefore, it is crucial for this to be as accurate as possible within the given time frame.

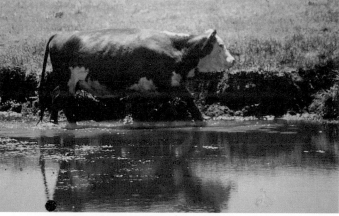

Reference Photo for *Marin Cow*
Notice the general full range of values in the animal, the landscape and the water.

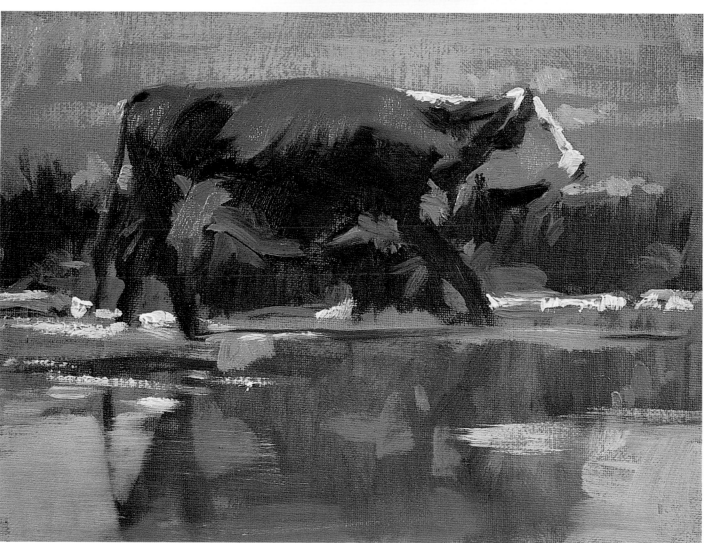

Two-Value Statement for *Marin Cow*
Study the photo. It is important to notice that the extreme lights and deeper darks are all details of form and changes that take place within the basic light and shadow forms. Therefore, before dealing with any subtle darker or lighter form undulations, it is fundamental to establish a good indication of simplified lights, shadows and basic shapes. The painting is now ready for further development.

MARIN COW • OIL • 20 MINUTES • 9" X 12" (23CM X 30CM)

Two-Value Statement in a Landscape

The two-value statement in a landscape can help you determine whether or not the drawing, composition and the basic light effects are working. If changes are called for, it is not difficult to increase the size of a tree, or intensify the light before going on.

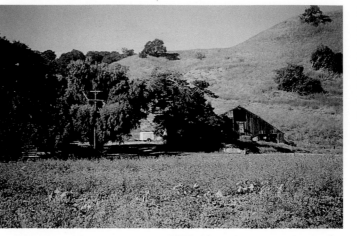

Reference Photo for *Hidden Old Barn*
It is obvious that the richness of color variations and subtle value transitions in this photo create an appealing image to paint.

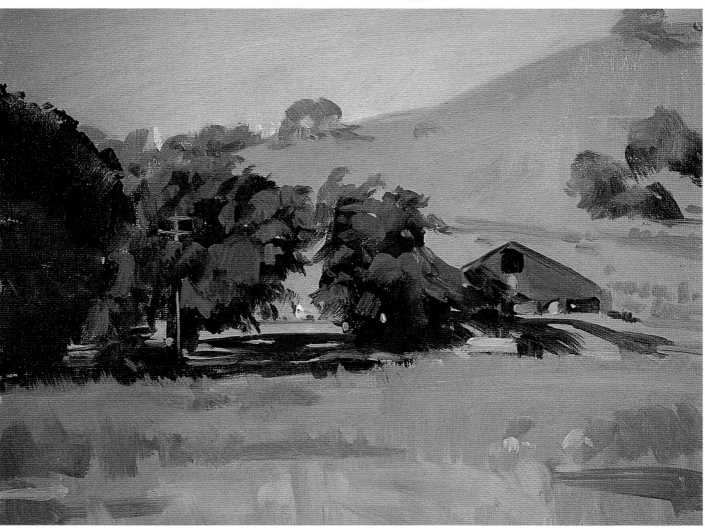

Two-Value Statement for *Hidden Old Barn*
This landscape composition may be analyzed by seeing the basic dark shapes of the trees and barn on the relatively light planes of the ground, the hills and the sky. As the background changes to foreground, the intensity of the color grows stronger. The simple approximation of value and color should be painted in with nos. 10 and 12 bristle filberts. First concentrate on the shadows then on the lights. Attention must be given to the various edge qualities of trees, architecture and the relatively flat ground planes. Once this is indicated to a satisfactory level, quick color modulations can easily be added for a feeling of vitality and refinement.

HIDDEN OLD BARN • OIL • 25 MINUTES •
11" x 14" (28CM x 36CM)

The Two-Value Statement Using the Figure

The figure is the focal point. You will have to deal with flesh, hat, hair, shirt, pants and shoes. A no. 6 bristle flat or filbert works great for the figure. Keep in mind that the two-value statement is not a complete statement, but sets the stage for the complete statement. In other words, one should not deal with any details in light or shadow forms until the two-value statement is complete.

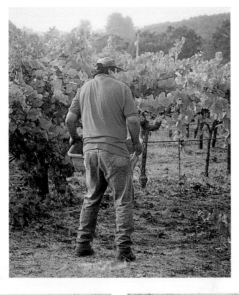

Reference Photo for *Working the Vineyard*
In complex subjects such as this, the two-value statement brings order and understanding to a very active composition.

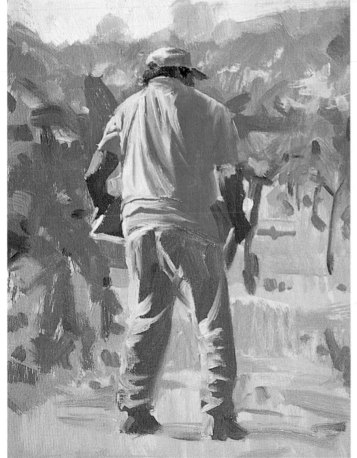

25-Minute Two-Value Statement of *Working the Vineyard*
It is important to first view this subject as background forms—basic vineyard foliage, ground plane and the figure. Each of these elements may further be broken down into simple lights and darks using nos. 8 and 10 bristle filberts.

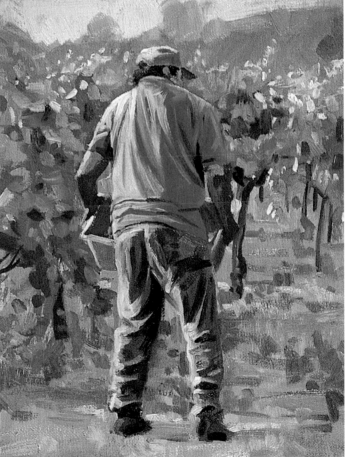

50-Minute Two-Value Statement of *Working the Vineyard*
A full 50-minute study allows for developing detail in both shadow and light. Detail is a matter of building subtle lighter and darker variations using smaller brushes—nos. 2, 4 and 6 bristle filberts. All detail should reinforce structure, subtle color variation and light quality. They should all be put down with bold conviction.

WORKING THE VINEYARD • OIL • 50 MINUTES • 12" x 9" (30CM x 23CM)

Block-In Technique

Understanding the concepts of sketching and painting is not too difficult because it is how most people view the process of painting. Creating a two-value statement is an obvious basic building block in every painting. A wonderful additional exercise for building confidence in both painting and drawing is the block-in technique.

The act of drawing without the use of lines or a rough sketch is achieved through starting a painting with a block-in. In this technique the subject is first analyzed through its basic shapes, values and colors. This technique creates masses of simple shapes, basic values and colors, and works them until they approximate the subject in a simple two-value image. Overlapping areas, pushing and pulling the paint, wiping off areas and carving out the necessary shapes add to the directness and character of the painting.

It is extremely important with this technique not to be afraid of being wrong. Have confidence and just go for it!

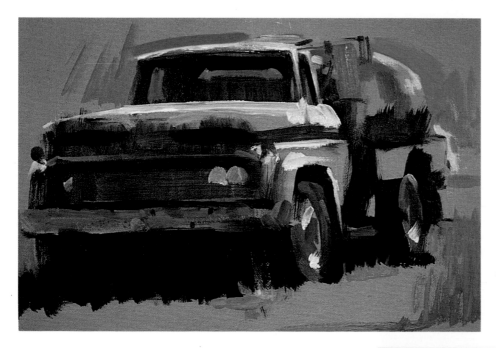

Block-In for *The Old Truck*

I began with a neutral, light gray-brown canvas. I used a no. 10 bristle filbert or flat to start massing in the basic dark, colorless, shadow-tone shapes. This gives a bit of form and drawing. I laid in some of the lights with light color variations using bold strokes. I worked down to smaller forms constantly thinking about mass. I used the background color to correct and carve the outside shapes as necessary. This is now a fresh lay-in ready for refinement.

The block-in technique for beginning a study tends to work the best in bold shape-oriented subjects; either light on dark or dark on light. Subjects in shadow will often work well since the dark shapes are usually easily identified.

THE OLD TRUCK • OIL • 20 MINUTES • 11" x 14" (28CM x 36CM)

Block-In of *Seated by the Window*

In painting figures, it is usually the detail of the individual that is the concern. When a figure is primarily in shadow, this form of particular detail can easily be simplified, and a block-in technique may be the best to use.

A light gray-olive toned canvas serves as a great ground for beginning this study. I used a no. 6 bristle filbert loaded with a dark, slightly muted warm fleshtone to mass in the basic head shape. I constantly check contours for proportion and keep a rough area for the lights. The large dark shape of the chair and blue-black blazer were massed in with a no. 8 bristle filbert, as were the slightly lighter and warmer trousers.

Next the dark fleshtone was added to the hand shapes. The shirt color is somewhere between the flesh and blazer, and was painted with a no. 6 bristle filbert. I mixed a tone slightly darker and warmer than the background to rough in the window frame and for the wall tone variations. I used white with a touch of Yellow Ochre loaded on a no. 2 bristle filbert to indicate the light as it strikes the figure. With a no. 10 bristle flat I painted the light in the window. A few darker tonal variations in the face add a bit of structure.

SEATED BY THE WINDOW • OIL • 30 MINUTES • 11" x 14" (28CM x 36CM)

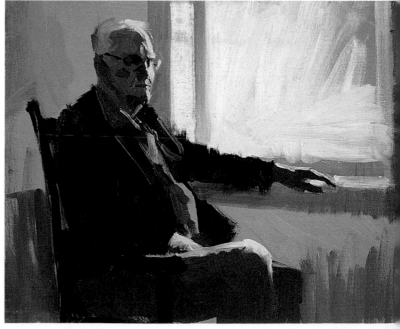

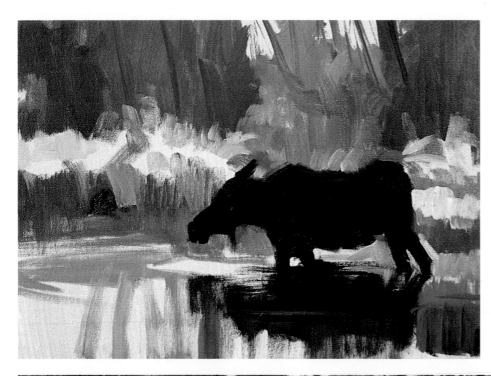

20-Minute Block-In for *No Manners*
As always, analyze the subject to be painted in its simplest context. On a light neutral toned canvas background, I massed in the tree forms with a bit of color variation using a no. 10 filbert. The middle ground, a mass of brush and weeds, has a shadow side similar to the background. All foliage should have a loose abstract quality (use your arm as you paint). A bit of activity in the water reflections and a large dark shape for the animal completes the block-in ready for refinement.

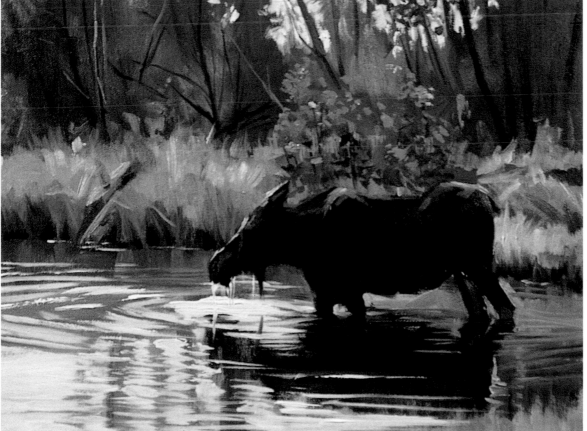

60-Minute Block-In for *No Manners*
A full 60 minutes was used to add color variations, various edge differentiation, lighting effects and details. Sky, branches, leaves, ripples and drips are all areas that were added at the very end, and were done with the smaller brushes—nos. 2 and 4 bristle filberts.

NO MANNERS • OIL • 60 MINUTES • 12" x 16" (30CM x 41CM)

Control Strokes

Variety in brushstrokes brings interest and vitality to a painting. When doing a quick study, there is not a great deal of time to consider various brushstrokes and their character. The lay-in is usually where the more active and energetic strokes occur. This is generally during the two-value statement. Whether a sketch-and-paint approach or a block-in approach is used in the beginning, the brushstrokes should be free and somewhat abstracted. It is the brushwork used for the refining stage that I wish to address at this point—control strokes.

Control strokes are the careful, quality strokes applied with a degree of sensitivity and discretion that brings finish during the refinement stage of the study. These strokes may refine form and structure, deal with negative spaces to refine edges and shapes, emphasize lighting, or add dark accents and calligraphic work to push deeper and more refined structure to a form. In any event, control strokes will bring a study to a sense of completion.

Create Form
A rough brushy lay-in of an apple shape is refined by carving an edge with the negative space. Form is created out of the flat mass with a little lighter red and a light highlight.

Create Simple Planes
A flat mass is turned into a nose with a darker tone for the underplane and eye sockets to create a bridge. Lighter form strokes lift out the simple planes of the nose and the wings. Final strokes control the highlights and the darker nostrils.

Use Negative Space
A brushy smear of olives and browns is turned into a group of trees by carving back into the shape with negative spaces creating tree trunks and foliage edges. A few calligraphic strokes add trunks and branches.

Create Light
A rough shadowy profile is refined with darker eyes, socket structure and warm cheekbone and dark upper lip shape. A few light strokes at the end gives a light source to the face.

The darks in and around the eye carve a depth in the eye socket area.

A simple dark warm slash firms up the nostril.

The dark mass below the chin creates a jaw line.

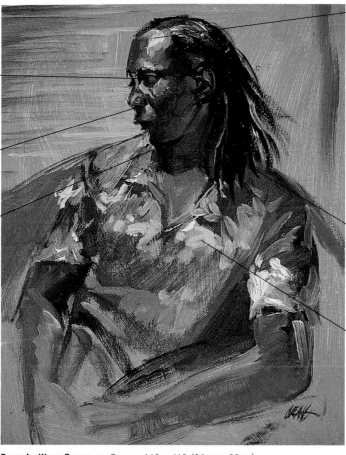

The light bold strokes on the forehead, the nose, below the eye, the top of the cheek-bone and to the right of the nostril give interior form to the head mass.

Dark flowing calligraphic strokes give the hair the appropriate look.

A few brighter bold yellow variations give sparkle and activity to the shirt.

BRIAN'S WILD SHIRT • OIL • 14" x 11" (36CM x 28CM)

The tree at the top left has been depicted with small strong positive strokes.

The firm crisp quality of the rocky cliff is defined by the bold variety of light strokes on the top.

The few strong darks at the base of the cliffs add recesses.

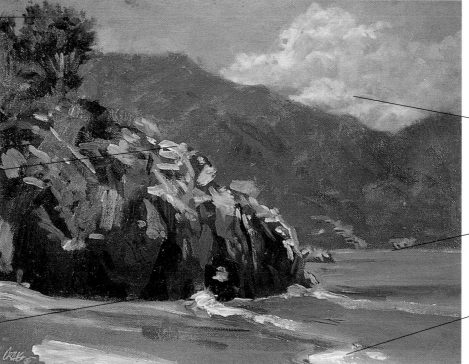

A light touch on the brush with white variations creates the clouds.

A lighter stroke on the beach and smaller strokes in the water finish off the base of the cliffs.

The powerful whiter areas in the water's foreground add the foam activity on the shoreline.

SUNNY BEACH • OIL • 11" x 14" (28CM x 36CM)

The Thought Process

An interior setting can offer a nice ambience or mood for a subject to paint, especially if there is a model that is available to pose within the setting. In this particular study it is important to note that there is a warm primary light source from the lamp and a cooler secondary light source from the right.

This breakdown of the painting process is helpful in approaching a quick study (or a finished painting for that matter). It is broken down by the percentage of time you should devote to each phase of painting.

Materials List

Paints

Alizarin Crimson • Burnt Umber • Cadmium Red Light • Cadmium Yellow Light • Cerulean Blue • Sap Green (Hooker's Green for acrylics) • Terra Rosa (Red Oxide for acrylics) • Titanium White (a soft formula for oils, Gesso for acrylics) • Ultramarine Blue • Viridian • Yellow Ochre

Brushes

Nos. 1, 2, 4, 6, 8, 10 and 12 hog bristle filberts • Nos. 4, 6, 8, 10 and 12 hog bristle flats • Large sable flat for oils • Large 2- to 3-inch (51mm–76mm) flat for acrylics

Mediums

Liquin for oils • Water for acrylics

Other

12" x 16" (30cm x 41cm) Masonite or canvas • Container—a plastic bucket for acrylics or a silicon jar for oils • Palette • Palette knife • Timer

0 to 20 Percent

► Choose the subject
► Analyze the subject
► Form your concept—what do you plan to achieve
► Understand the time frame—25, 45 or 60 minutes
► Compose
► Begin sketch or block-in

20 to 40 Percent

► Evaluate and correct (if necessary) and check time
► Work up two-value statement

40 to 65 Percent

► Re-evaluate and correct (if necessary) and check time

65 to 85 Percent

► Begin developing form
► Work in value variations
► Work in color manipulations

► Re-evaluate and correct (if necessary) and check time
► Begin refining
► Check edges

85 to 100 Percent

► Re-evaluate and correct (if necessary) and check time
► Take care of any problem areas

100 Percent

► Refine and accent focal point
► Complete

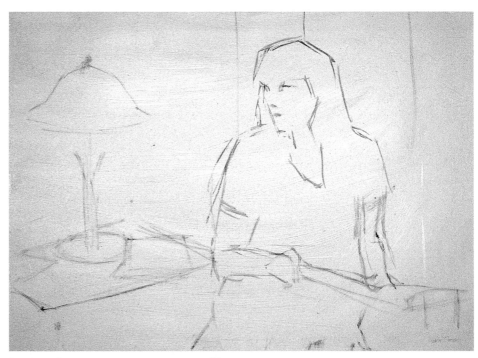

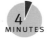

[STEP 1] On a warm light neutral toned piece of Masonite, quickly draw a linear sketch of the composition using a no. 2 bristle filbert.

4 MINUTES

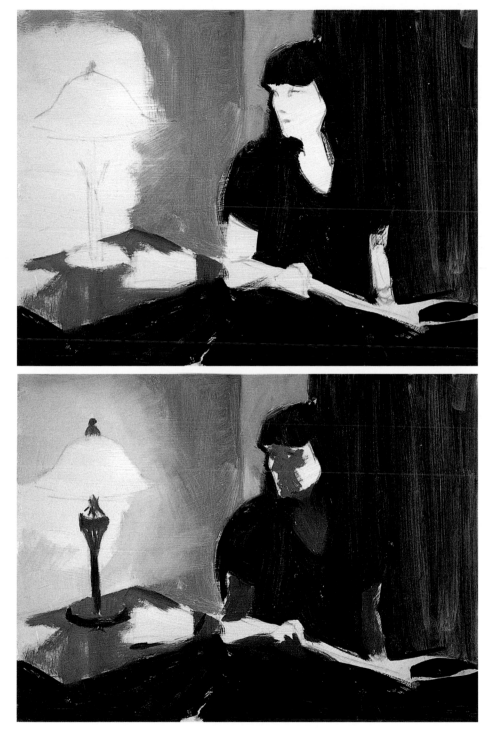

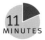

[**STEP 2**] Study and unify the simple dark shapes of the dress, the hair, the shadow of the table and a variation for the drapes. Lay this in with a no. 10 or 12 bristle filbert. Block-in a Yellow Ochre variation for the walls and a warmer earth tone for the tabletop.

[**STEP 3**] Focus on the shadow fleshtone, which is similar in value to the tabletop but not as warm. Boldly paint the darker lamp base and a lighter warm glow on the wall with a no. 8 bristle filbert.

Good Paintings

All good painting is based upon confidence, conviction, action, evaluation, adjustment, re-conviction, action, evaluation, adjustment, reconviction etc!

[**STEP 4**] Complete the two-value statement with the nos. 6 and 8 bristle filberts. The primary concern should be on the two different light sources affecting the fleshtone and how they define the form (warm from the left and cool from the right). A touch of Ultramarine Blue and white in the fleshtone works to keep the cool light on the right side of the face. Add some dark masses to the books.

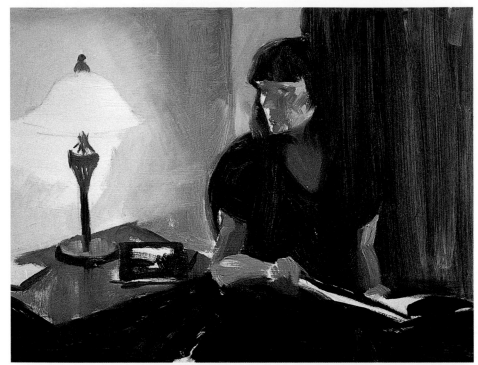

[**STEP 5**] Use a no. 6 bristle filbert to add some light color to the glowing lampshade and some detail to indicate the lamp base and the book. The bright illumination from the lamp affects the tabletop. It is important to begin to define the form on the face, the arm and the hand with a warm light from the lamp (white, a little Cadmium Yellow Light and a little Cadmium Red Light). Note the cool shadow of the book's pages. A no. 4 bristle filbert is best for this, but a no. 2 bristle filbert will work as well.

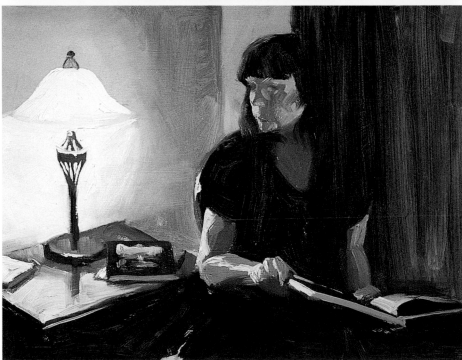

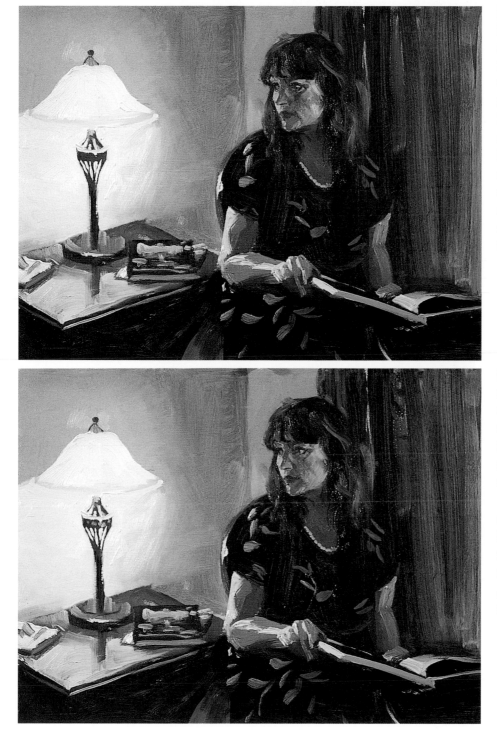

[**STEP 6**] Now slow down and begin reinforcing a bit more facial structure with a no. 2 bristle filbert using more sensitivity. Some subtle value manipulation sets up the details of the features, namely the eyes, nostril and lips (these are generally darker accents). Add a bit of light soft tonal variation in the hair with a no. 2 bristle filbert to add a bit of life. Add the necklace and pattern on the dress. Add life and sparkle to the picture using very simple strokes. Delicate but firm strokes add a little pattern to the curtains for interest.

[**STEP 7**] Quickly evaluate the painting. Make some adjustments mainly in the face with a no. 2 bristle filbert. Add a few subtle drawing and structure corrections to the eye and mouth area. Also add some small subtle detail to the top of the lamp base.

This is basically a completed quick study taking about 55 minutes. The basic look is achieved through quick observations and indications, but a few adjustments seem to be called for.

INTERIOR ILLUMINATION • OIL • 60 MINUTES • 12" x 16" (30CM x 41CM)

The 25-Minute Study

The 25-minute study is a great exercise to loosen up and develop brushmanship, editing and quick decision making. Generally smaller formats such as 8" × 10" (20cm × 25cm), 9" × 12" (23cm × 30cm) or 11" × 14" (28cm × 36cm) work the best, as do larger brushes (nos. 8, 10 and 12). The key is indication not overrefinement. Still life works well for this 25-minute exercise.

Materials List

Paints

Alizarin Crimson • Burnt Umber • Cadmium Red Light • Cadmium Yellow Light • Cerulean Blue • Sap Green (Hooker's Green for acrylics) • Terra Rosa (Red Oxide for acrylics) • Titanium White (a soft formula for oils, Gesso for acrylics) • Ultramarine Blue • Viridian • Yellow Ochre

Brushes

Nos. 1, 2, 4, 6, 8, 10 and 12 hog bristle filberts • Nos. 4, 6, 8, 10 and 12 hog bristle flats • Large sable flat for oils • Large 2- to 3-inch (51mm–76mm) flat for acrylics

Mediums

Liquin for oils • Water for acrylics

Other

10" × 13" (25cm × 33cm) Masonite or canvas • Container—a plastic bucket for acrylics or a silicon jar for oils • Palette • Palette knife • Timer

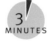

[**STEP 1**] On a 10" x 13" (25cm x 33cm) neutral toned prepared Masonite board, quickly sketch a composition of simple geometric shapes. Depict the copper pot and the basic daisy shapes using a no. 2 bristle filbert.

3 MINUTES

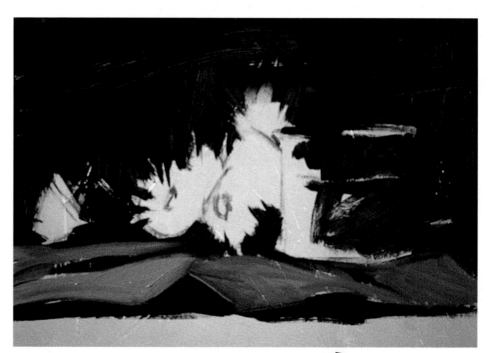

[**STEP 2**] Work from background to foreground. Mix up a dark neutral background tone of Burnt Umber and Ultramarine Blue. Use a no. 10 bristle filbert to block in the background, followed by the foreground plane and approximate cast shadows using lighter and warmer tones.

5 MINUTES

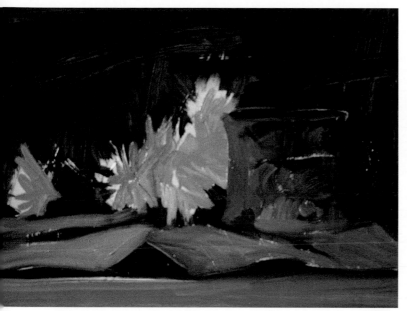

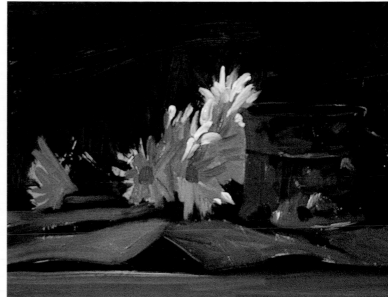

[**STEP 3**] Still using the no. 10 bristle filbert, turn your attention to the forms, concentrating on their form shadows. There is a warm single light source that causes the form shadows of the white daisies to appear somewhat cool; therefore a slightly grayed blue-violet works well. For the copper pot, a color close in value to the background tone is more appropriate. Bring in the warm brown of the tabletop at the bottom, and the warm copper or orange on the pot.

6 MINUTES

[**STEP 4**] Switch to the no. 8 bristle flat. Focus your concentration on the form lights, primarily the warm lights on the daisy petals. Instead of being overly concerned about the exactness of each petal, use the tip of the brush to roughly indicate the light pattern with Titanium White and a touch of Yellow Ochre. Do a little corrective work on the pot along with a few cool reflections in it. Notice a bit of reflective warm light within the shadows of the daisies and indicate the shadows.

6 MINUTES

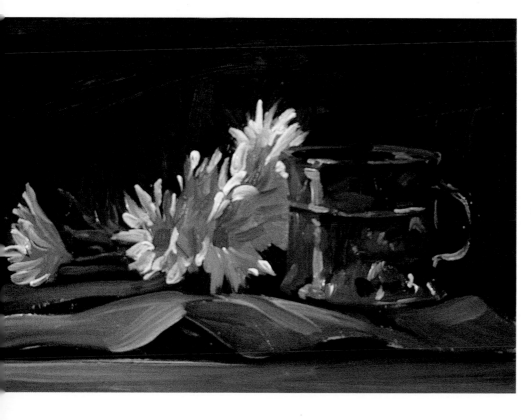

[**STEP 5**] Make sure the light pattern on the daisies appears correct. Then finish the lights on them, being somewhat careful to give the correct feeling to the petals. Add the centers of the daisies. Notice that they are all in shadow. Finish the sparkles and warm highlights in the pot, its handle, and a bit more light on the ground plane fabric for the final touches.

5 MINUTES

COPPER AND DAISIES • OIL • 25 MINUTES • 10" x 13" (25CM x33CM)

The 45-Minute Study

This longer study allows for a more complex subject matter such as a figure. Moving away from simple forms and on to more organic and flowing forms will require more time and a different way of thinking. A figure outdoors in sunlight is always fun and a challenge.

Materials List

Paints

Alizarin Crimson • Burnt Umber • Cadmium Red Light • Cadmium Yellow Light • Cerulean Blue • Sap Green (Hooker's Green for acrylics) • Terra Rosa (Red Oxide for acrylics) • Titanium White (a soft formula for oils, Gesso for acrylics) • Ultramarine Blue • Viridian • Yellow Ochre

Brushes

Nos. 1, 2, 4, 6, 8, 10 and 12 hog bristle filberts • Nos. 4, 6, 8, 10 and 12 hog bristle flats • Large sable flat for oils • Large 2- to 3-inch (51mm–76mm) flat for acrylics

Mediums

Liquin for oils • Water for acrylics

Other

16" x 12" (41cm x 30cm) Masonite or canvas • Container—a plastic bucket for acrylics or a silicon jar for oils • Palette • Palette knife • Timer

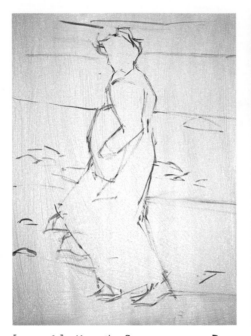

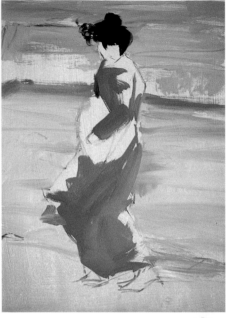

[**STEP 1**] Keep the figure central to the composition. Sketch the figure on a light neutral toned 16" x 12" (41cm x 30cm) piece of Masonite with a no. 2 bristle filbert. Concentrate on proportion, gesture and where the background elements of the beach might intersect the figure. Don't paint any details.

3 MINUTES

[**STEP 2**] Study the tones and colors in the background, approximate them using a no. 12 bristle filbert with enough color variation and lightness to create the sunlit quality, keeping the brushwork abstract and free.

Study the color and value within the shadow of the white dress, keeping it cool as affected by the color of the sky. Use a no. 10 filbert with loose flowing brushwork to capture the wind. Finally add the dark loose accent of the hair with a light touch on the brush.

8 MINUTES

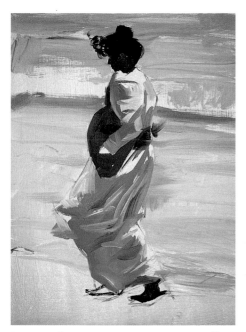 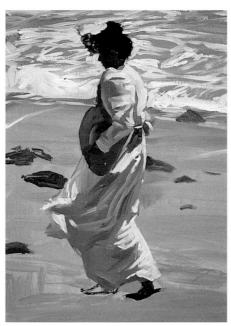 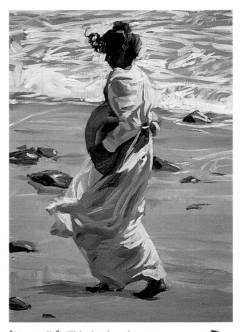

[STEP 3] Use the no. 10 bristle filbert to stay with the figure. Notice the richness and variations within the shadow of the garment. Build into the base shadow tone; add in subtle reflected lights and slightly darker folds in the dress indicating subtle warms and cools.

Work the form shadow areas in the flesh with a darker warm tone. Paint the straw bonnet darker and warmer than the garment.

[STEP 4] Pay attention to the form lights. These are affected by warm sunlight, as is the foaming action of the surf. Begin with the no. 10 bristle filbert in the surf using a very warm white (Titanium White with a little Yellow Ochre) and keep the paint very wet using medium and a little turpentine. Use the brush with a light touch to indicate the action and movement of the surf.

Indicate a few rocks to help break up the sand, using firm strokes. Load a no. 8 filbert with a warm white to create the sunlight and emphasize the lights on the rocks. Pay attention to the light pattern and edge control within the form of the dress. Indicate the dry beach area in the foreground in an abstract quality.

[STEP 5] This is the time to slow down a bit and add some finish or refinement. Add the other foot and the cast shadow with a no. 8 bristle filbert. The hair needs a bit more light on it and a better edge quality to air it out in the wind. Give a little refinement around the hand with a no. 2 bristle filbert, and add the whipping ribbon of the hat to create some movement. Delicately paint a little subtlety in the face using warm reflected light and a darker eye indication. Finally add a little light on the rocks and the surf action around them.

A Brisk Breeze • Oil • 41 minutes • 16" x 12" (41cm x 30cm)

The 60-Minute Study

A landscape with atmospheric and sunlight effects is a great subject for a 60-minute study. The techniques used in this landscape are a little more complicated so more time is needed for this complex subject. Use a 14" × 18" (36cm × 46cm) light warm neutral toned piece of Masonite or canvas.

Materials List

Paints

Alizarin Crimson • Burnt Umber • Cadmium Red Light • Cadmium Yellow Light • Cerulean Blue • Sap Green • (Hooker's Green for acrylics) • Terra Rosa (Red Oxide for acrylics) • Titanium White (a soft formula for oils, Gesso for acrylics) • Ultramarine Blue • Viridian • Yellow Ochre

Brushes

Nos. 1, 2, 4, 6, 8, 10 and 12 hog bristle filberts • Nos. 4, 6, 8, 10 and 12 hog bristle flats • Large sable flat for oils • Large 2- to 3-inch (51mm–76mm) flat for acrylics

Mediums

Liquin for oils • Water for acrylics

Other

14" x 18" (60cm x 46cm) Masonite or canvas • Container—a plastic bucket for acrylics or a silicon jar for oils • Palette • Palette knife • Timer

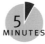

[STEP 1] Use a no. 2 pencil to sketch in the large masses. Create the basic shapes that make up the composition. Lay in a light sky color that becomes lighter and warmer on the right, where the sunlight is coming from. Use a no. 12 bristle flat. Overlap into all the linework, working from background to foreground.

5 MINUTES

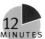

[STEP 2] Because of the atmospheric conditions, the background appears lighter and softer than the foreground. With this in mind, use a no. 12 bristle flat to lay in the background mass—a grove of trees—using a soft and light neutral gray-green. Give special attention to the trees' edges. Work towards the foreground. Keep the gray shapes of the foreground foliage darker than the foliage in the background. At this stage you want to create subtle warm and cool color variations and an overall value pattern.

12 MINUTES

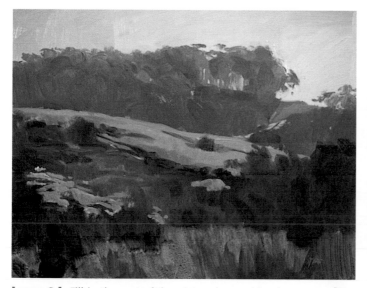

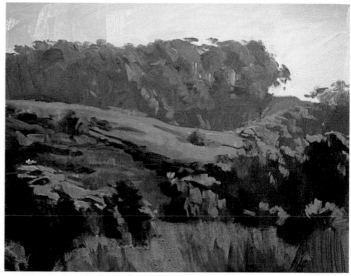

[**STEP 3**] Fill in the rest of the picture by washing in the foreground underbrush with a no. 10 bristle flat using two values of grayed-ochre. Next use the no. 10 bristle flat to lay in the pink heather with a bit more color intensity at the base. Go back to the dark foliage and add the tree shapes in the foreground, overlapping the mass of pink flowers.

12 MINUTES

[**STEP 4**] Give some dimension and light effects to the various tree masses. Stay with the no. 10 bristle flat and mix up a variety of light olive greens using Yellow Ochre for a base to create a sunlight effect. Work to keep the value contrast closer in the background and stronger as it gets closer. Take a no. 8 bristle flat and add a few tonal and intensity variations into the pink heather. Keep it subtle.

12 MINUTES

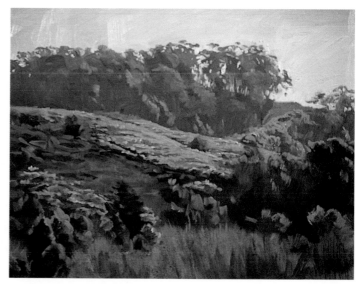

[**STEP 5**] It is necessary to complete the sunlight, or backlighting, effect on the tree forms, with special attention to the edges and textures. Emphasize this more on the foreground trees. Add a bit of light to the pink floral masses and within the shadow of the tree forms. Add a bit of subtle shadow detail.

12 MINUTES

[**STEP 6**] Slowing down for final decisive strokes, take note that the background trees could use some sensitivity in the edges of the tree shapes. Use a no. 6 bristle flat with a full load of wet, lighter pink paint to enhance the heather with some light textural strokes, adding a touch of brighter pink here and there as it appears.

7 MINUTES

THE PINK BLANKET • OIL • 60 MINUTES • 14" x 18" (36CM x 46CM)

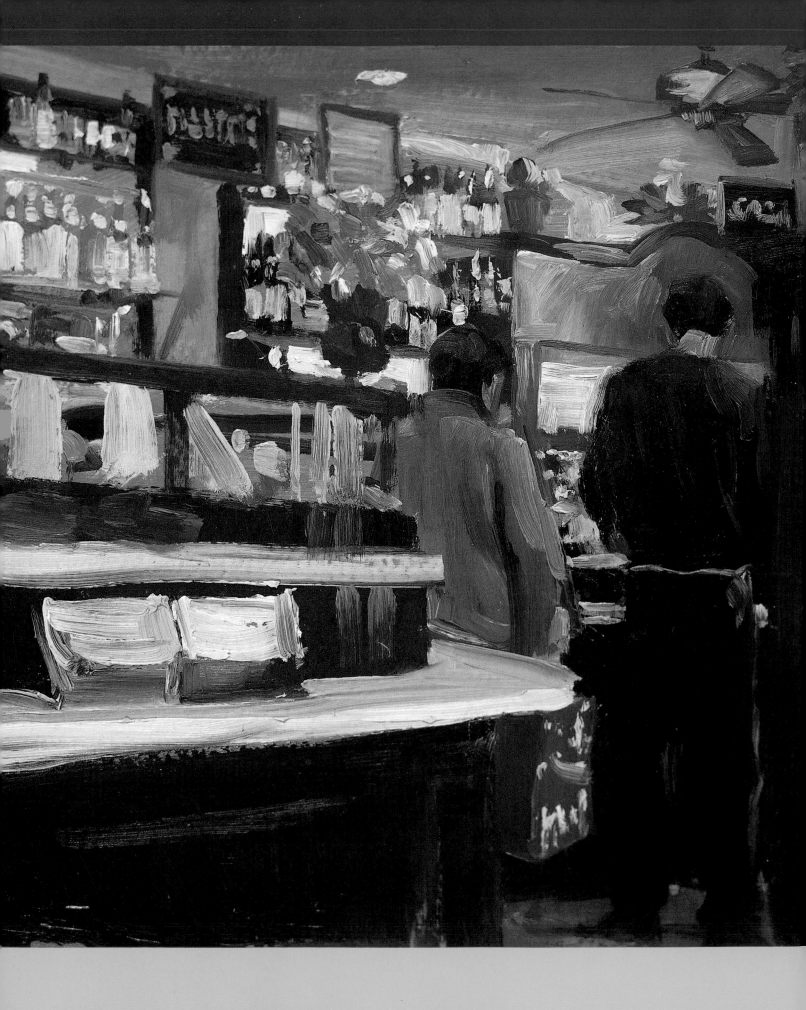

Editing

Editing, in painting, is the elimination of unnecessary detail. It breaks down the elements to their bare essentials, leaving out details that are not needed. The basics of editing is to simplify, or understate, but still describe the shape (drawing) and local color and value. Some indication of form also contributes to the essentials of a subject. Just how refined the form should be is an artistic choice for each painter. In all forms of painting, editing is necessary. A beginning painter may wish to ensure accuracy by adding all explicit detail. This will create a static and boring painting. It is by editing out what is not necessary, that a painter may gain control of the painting.

The quick study will force a painter to put down the larger essentials and refine only what there is time for. This requires quick analysis, conviction and simplification. A near circular shape must become a sphere-like form before it becomes an apple. A face must take form as a head before it becomes a portrait, and a landscape must be a configuration of shapes before it takes form as specific hills, trees and foliage.

Focus on Perspective

Perspective is the first thought approaching a subject such as this. All horizontal lines must converge at the same vanishing point. With that in mind, the dark shapes can all be painted using the no. 10 bristle flat, to quickly establish the composition and basic value pattern. The rest of the study is a matter of blocking in the larger simple shapes. The finishing touches on the activity in the background are very simply indicated with a no. 2 bristle filbert.

MORNING ESPRESSO • OIL • 60 MINUTES • 12" x 16" (30CM x 41CM)

Deciding What Is Important

The most important aspect of a quick study is the editing that each artist makes. This requires rapid and confident decision making. You must decide what is important to the subject as well as what is important to you. For example, the accuracy of shape and size may be important to the subject, while the mood and lighting may be important to you.

How important is something within a given setting? In a quick study, if something is not essential to capture the subject, then it can be left out. When painting in this abbreviated style, you must leave out unnecessary details. The best way to approach this is to think of your strokes as rapid indications of shapes, values and colors—not details.

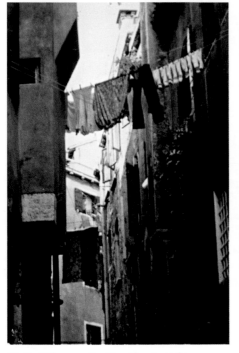

Photo Reference for *Venetian Laundry*

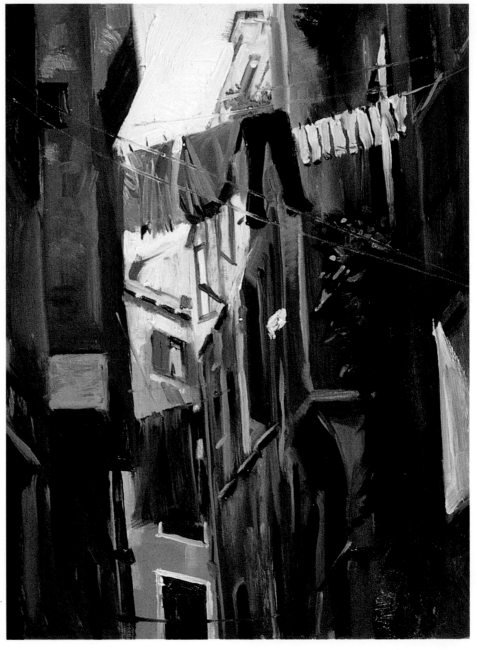

Simplify the Scene
The powerful design of sky and architecture is simplified from the photograph. Within the short time frame of the study, enough detail is indicated to give believability to the scene. In the study the perspective is important and relatively accurate while much of the detail is understated or deleted.

VENETIAN LAUNDRY • OIL • 60 MINUTES • 16" x 12" (41CM x 30CM)

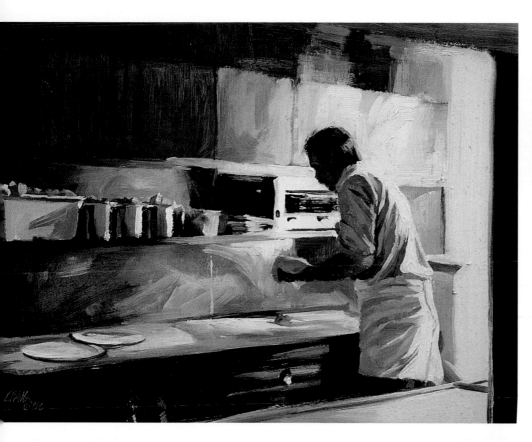

Photo Reference for *Pizza in Cortina*

Editing Unwanted Elements

The mood, linear breakup of space, and action of the figure are all important elements. In the photo reference there are additional elements in the foreground and on the sides that detract from the subject matter; therefore they are edited from the composition. This gives the content more readability and helps clarify the activity.

PIZZA IN CORTINA • OIL • 60 MINUTES • 11" x 14" (28CM x 36CM)

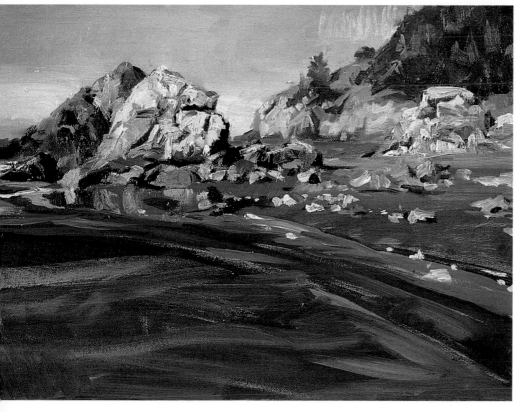

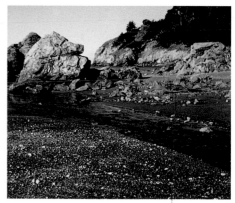

Photo Reference for *Marin Rocks*

Capture the Scene Without Details

In *Marin Rocks*, the photograph shows a rich field of textural pebbles and an abundance of crags and crevices in the rock formation. By simplifying and editing the look and integrity, the scene is captured without the overwhelming details.

MARIN ROCKS • OIL • 45 MINUTES • 12" x 16" (30CM x 41CM)

What Is the Essence of the Subject?

The essence of any subject can be found in its basic components. It is the unique elements that make the subject special. This will usually be its shape or shapes. It can also be the lighting effects, texture, design or color of the subject. Is it large or small? Simple or complex? Gray and dull or bright and colorful? How does it relate to other objects or the overall composition? It is the essence of a subject that is always the goal in a quick study.

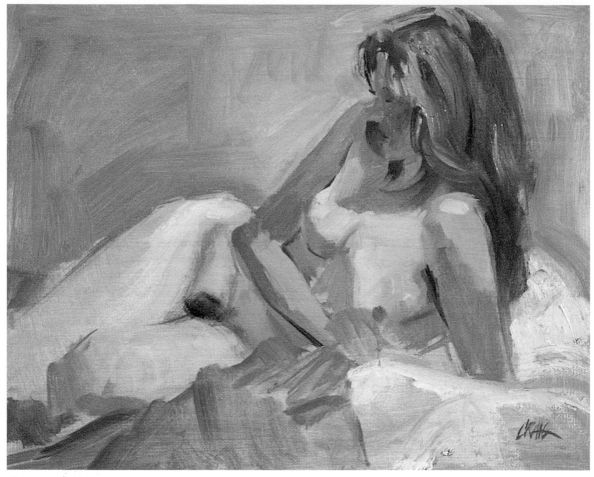

The Essence of the Figure
The essence of *Redhead Study* is the pose, the gesture and proportions (This is almost always true when painting the figure.) This is captured through the creation of simple shapes of light and shadow (the two-value statement). Layered on top of that is a minimal modeling within the lights and a few dark accents in the shadows.

REDHEAD STUDY • OIL • 30 MINUTES • 11" x 14" (28CM x 36CM)

Simplify!

One of the benefits of doing a quick study is that you must simplify what you see in order to complete your painting in a short time frame. You must begin with large simplified shapes and leave out superfluous details. Simplification is best achieved through the use of large brushes (nos. 10 and 12) and avoiding smaller brushes (nos. 2, 4 and 6) as long as you possibly can. When simplifying it is beneficial to squint or blur your vision as you view your subject. This will help eliminate detail.

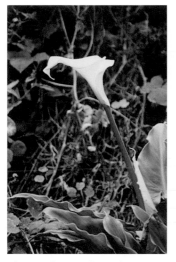

Photo Reference for *Intimate*

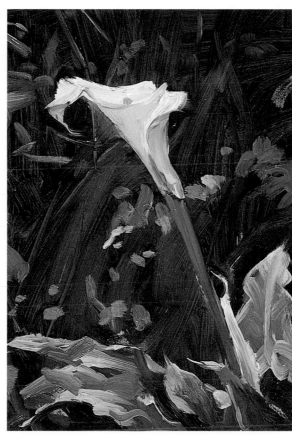

Simplify the Background
The photo reference used for *Intimate* shows everything that is seen. By editing out what is unnecessary and simplifying what is left, we find the essence of the subject. This is dominated by the shape of the calla lily and supported by the leaves at the bottom.

INTIMATE • OIL • 30 MINUTES • 12" X 9" (30CM X 23CM)

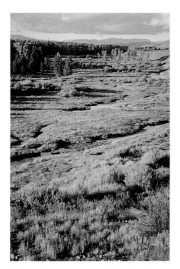

Photo Reference for *The Snake in Autumn*

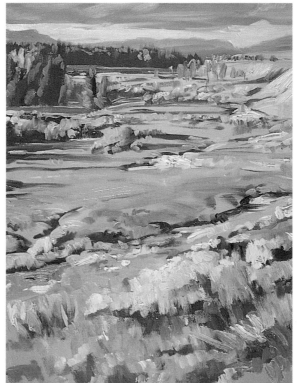

Large Brushes Simplify Shape and Mass
The reference photo shows the large expanse of landmass punctuated by the Snake River. In the foreground is a large textural mass of dry brush and bushes. The entire landscape has a textural quality. The use of nos. 10 and 12 brushes keeps the landmass simple. A few darker indications for trees and shadows simplifies the basic dark tones. The river reflects the bold light blue of the sky, completing the effect.

THE SNAKE IN AUTUMN • OIL • 60 MINUTES • 16" X 12" (41CM X 30CM)

Seeing in the Proper Order

The first step to take in any study is a quick analysis of the subject. You must understand the dominant shapes and tones; the darkest dark, the lightest light and the most intense color. Once this is decided, it is important to see your subject in the proper order.

In the beginning it is important not to look at the detail. Find the large masses underneath the detail. Once the first simplified layer of masses or tones are blocked in, focus on breaking up those masses with slightly smaller color and tone variations—these are most likely structural changes. Move from one area to another being careful not to dwell on any one spot. Continue to break down masses into smaller, darker or lighter shapes that slowly define the subject until all the essential forms are indicated.

The demonstration, *A Red Topping*, shows the order in which elements of a study should be observed.

Materials List

Paints

Alizarin Crimson · Burnt Umber · Cadmium Red Light · Cadmium Yellow Light · Cerulean Blue · Sap Green (Hooker's Green for acrylics) · Terra Rosa (Red Oxide for acrylics) · Titanium White (a soft formula for oils, Gesso for acrylics) · Ultramarine Blue · Viridian · Yellow Ochre

Brushes

Nos. 1, 2, 4, 6, 8, 10 and 12 hog bristle filberts · Nos. 4, 6, 8, 10 and 12 hog bristle flats · Large sable flat for oils · Large 2- to 3-inch (51mm–76mm) flat for acrylics

Mediums

Liquin for oils · Water for acrylics

Other

16" x 12" (41cm x 30cm) Masonite or canvas · Container—a plastic bucket for acrylics or a silicon jar for oils · Palette · Palette knife · Timer

[**STEP 1**] Complete a quick two- or three-minute sketch of the basic shapes using a no. 2 filbert on a piece of light neutral toned Masonite. Use a no. 10 or 12 bristle flat loaded with blue variations (a lighter blue-violet for the sky and a little more Cerulean Blue for the blue-green of the water).

 3 MINUTES

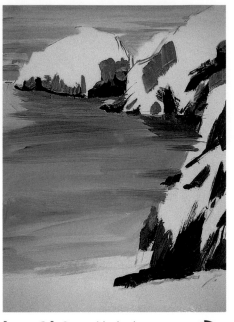

[**STEP 2**] Stay with the large brushes. Observe the large simplified dark tones created by the light. Notice how the light creates the surface changes and local color changes in the rocks. A mixture of Burnt Umber, Ultramarine Blue and a touch of Alizarin Crimson, with a bit of white for the slightly lighter darks, should all be indicated with a large brush. A slight violet tone brought into the water adds a reflection of the rocks.

10 MINUTES

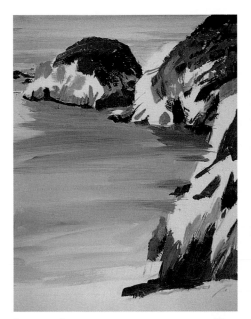

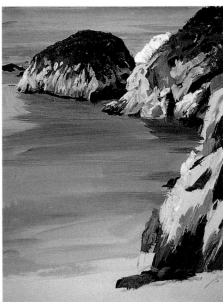

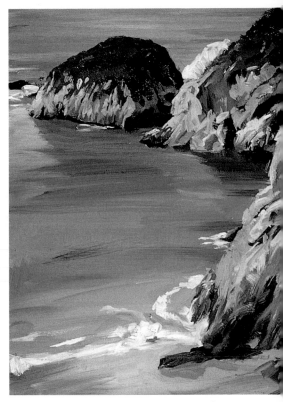

[**STEP 3**] Along with the simple dark tones, some top growth on the rocks begins to blend into the shadows. Add the warm color variations that occur in the growth, and some subtle tonal variations in the shadows to create a feeling of depth. Use a no. 10 bristle filbert for this stage.

15 MINUTES

[**STEP 4**] Now turn your attention to the light areas. Mix up a light warm tone using white, a little Yellow Ochre and a touch of Terra Rosa. Fully load a no. 8 bristle filbert and begin chunking in the lights on the rocks with a thick load of paint. Use thick, bold strokes, as if you are sculpting the surface. Also enhance the red growth on the back rock with a touch of Cadmium Red Light. Bring in the gray-green growth on the same rock.

15 MINUTES

[**STEP 5**] Use the no. 8 bristle filbert and turn your attention to the foreground sand, a close color variation on the tone of the Masonite. Drag your wet tonal variations to match the movements in the sand. With an off white (Titanium White and a touch of Yellow Ochre), mix a wet load of paint and with a no. 6 bristle filbert delicately apply the white surf as it meets the shore and the rocks. Finally add a touch here and there in the rocks and water for a bit of refinement.

12 MINUTES

A Red Topping • Oil • 55 minutes • 16" x 12" (41cm x 30cm)

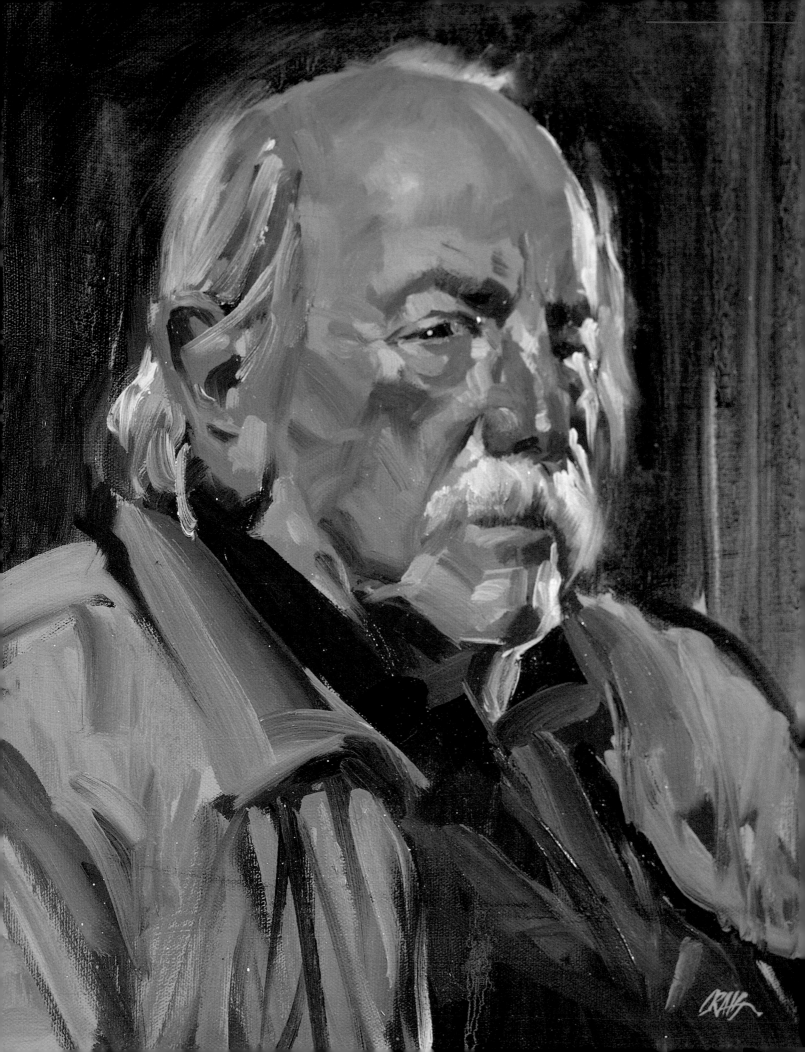

Build Brush Confidence

Confidence in brush handling is a matter of sensitively developing the feel of the brush in your hand. This includes the touch on the canvas, the firmness or softness of stroke, the load of paint, the wetness or dryness of the paint and the facet of the brush that applies the paint. This is much like a concert pianist developing a sensitivity to the keys and foot pedals. Confidence in anything comes from repetition, and repetition leads to comfort and the mastery necessary to excel. Painting more quickly will lead to truly using the brush as a painting tool, not just an instrument for filling in between the lines.

Brush confidence is evident when it flows naturally. Great brushwork is like watching a flawless dance performance. Everything fits together and naturally feels as if it belongs. This is a lifelong pursuit and the quick study will help accelerate the avenue to better painting.

90 Minute Study
This is a longer, more developed study, dealing with likeness, facial structure and character development. The longer study and focus on the face allows for more build up of flesh tone coloration and subtle structural development.

GOOD OL'JERRY • OIL • 90 MINUTES • 16" x 1426" (41CM x 30CM)

CHAPTER 4

Brush Confidence

If you look at a John Singer Sargent painting, you can admire the incredible facility he had with the brush. His sensuous strokes convey authority, conviction and the utmost confidence. This type of confidence can only be achieved through constant practice and repetition.

There are many factors in making great brushwork. These include the painting surface, the consistency of the paint, if the stroke is applied to a wet or dry area, the amount of paint on the brush, how much pressure is applied during the stroke and the type and quality of brush used. These factors are a lot to consider, but, through your practice on quick studies, much of the sensitive feeling for the brush will eventually become instinctual.

Expressive Brushstrokes

When one thinks of brushstokes and their characteristics, it may bring to mind the lyrical strokes of Vincent van Gogh, the staccato style work of Claude Monet, the rich textural work of Nicolai Fechin or even the powerful blocky work of California painter Edgar Payne. The contemporary work of Wayne Thiebaud employed creamy, sensuous strokes in his pies, pastries and ice cream. In these cases, their brushwork brought out their individuality or uniqueness.

The type of a brushstroke brings out the characteristics of the subject when properly used. For example, firm edges depict crisp forms such as architecture. Soft edges may deal with the sensitive turning of a form as in a figure or fabric. Ragged or textural edges may show brush or trees. Flat strokes may show flat planes and wet-into-wet strokes may show softer color and value changes such as clouds.

Create Character With Your Brushstrokes

In this study, the architectural columns are created with a deliberate vertical firm stroke. The foreground grassy plane is relatively flat and absent of texture. As the light affects these areas, it is treated very simply through basic warm light and cool shadow. As you approach the foliage, it is very free and organic. Using a light grip on the larger bristle filberts and flats and varying stroke directions give the leaves and dry brush the appropriate character. The railing and smaller foreground plants and flowers are achieved using a no. 1 bristle filbert and a no. 1 bright.

MISSION LIGHT • OIL • 60 MINUTES • 14" x 11" (36CM x 28CM)

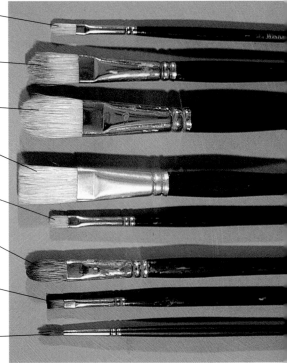

No. 1 hog bristle filbert—good for sketching and soft, or sharp, detail.

No. 8 hog bristle filbert—good for very small painting and medium detail.

No. 10 hog bristle filbert—good basic workhorse for blocking in masses.

No. 12 hog bristle filbert—great for architecture, large planes and grassy fields.

No. 1 hog bristle bright—good for sketching and firm detail.

No. 12 synthetic mongoose or sable filbert—great for fabric or head painting.

No. 6 synthetic mongoose or sable flat—great for finishing or refinements.

No. 4 synthetic sable or sable round—great for linear detail (tree branches).

These are most, but not all, of the brushes necessary for quick studies. As you gain experience you will add your personal favorites.

Brushstrokes Create Details

The size, shape, or type of brush is definitely important in the character of any painting. In a quick study the economy of a stroke is also an important consideration. How much can be accomplished with the least amount of effort? Using the right size and shape of brush at the appropriate time will give a seemingly effortless effect to the study and make the painting more enjoyable to paint as well.

Study the cropped details of the paintings in this chapter. Notice the various subjects and the brushwork that indicates them.

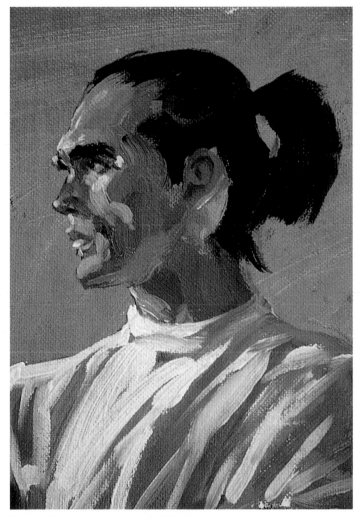

Use Brushstrokes to Create the Figure
This head and shoulders are done with a no. 8 bristle filbert primarily and final refinements are with a no. 1 bristle filbert and a no. 6 flat sable. The final strokes are more careful and deliberate.

Use Large Bristle Flats for Loose Brushwork
This detail of a field study shows a lot of brush and weeds originally painted with a no. 12 bristle flat delicately lifting up to achieve the brushy edges, a no. 1 bristle filbert and no. 4 sable round indicated the smaller details.

Use Small Bristle Filberts for Refinement
This detail of the *Palace of Fine Arts* field study was achieved with a no. 8 bristle filbert to lay in basic shapes and a no. 1 bristle filbert for refinements and indications of detail.

Balance Vigorous Brushwork With Simplicity
This yellow onion on top of a book shows the vigorous brushwork done with nos. 8 and 10 bristle filberts and the layering of local color variations before the highlights. The simplicity of the book contrasts this.

Combine Different Brushes for Different Effects
This upper torso and head study was begun with a no. 10 bristle filbert for the large underlying masses, then a no. 8 bristle filbert was used for the overlapping smaller planes and finally the no. 12 sable filbert and no. 6 sable flat for refining.

Use a Small Bristle Filbert for Crisp Detail
This example was done with a no. 12 bristle flat for the background and a no. 8 bristle filbert for larger tones of yellow and red variations; the smaller crisp highlights of the glass are done with a no. 1 bristle filbert.

Different Types of Brushwork

Certain subjects have characteristics that require a specific type of brushwork. You may use brushwork that is active and rapid, or slower and more deliberate; your brushwork may even be softer and more delicate.

All are necessary ingredients for most paintings and studies.

Although the choice of brush is important, the paint consistency (how wet or dry) plays a tremendous role in the quality of

brushstrokes. The load of paint—how much paint is on the brush—is also a big factor in brushwork. Together, these greatly affect the various stroke characteristics.

Using Defining Light
The backward thrust of the arms shows the prominence of the scapula and gives a lot of visible structure to this back view. The basic light and shadow is created by light from the upper right; this is depicted by the final lights, layered on top of the basic light fleshtone with no. 8 and no. 1 bristle filberts.

LLOYD'S BACK • OIL • 40 MINUTES • 18" x 14" (46CM X 36CM)

Limiting Your Brushes
This quick study was achieved through bold vigorous brushwork with nos. 8 and 10 bristle filberts (no time for a lot of brush changes). When using only two brushes, it is important to use your paint rag to keep wiping excess paint from the brushes.

TWO LEMONS AND COFFEE • OIL • 25 MINUTES • 10" x 8" (25CM X 20CM)

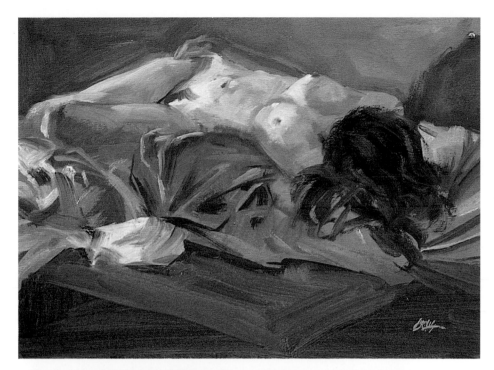

Painting With a Delicate Touch

A pose such as this requires a different way of looking at the figure. You must see it as a form and a variety of overlapping shapes with soft light and shadow tonal transitions. The larger shapes of the background and underlying fabric tones were painted with a no. 12 bristle flat. The majority of the figure was painted with a delicate touch using a no. 8 bristle filbert with a lot of concentration on edge control.

LYING DOWN • OIL • 40 MINUTES • 12" x 16" (30CM x 41CM)

Complex Subject Matter

There is a lot to consider here: trees, architecture, water in motion and a figure. All of these elements require different brush treatments. The no. 12 bristle flat with a somewhat dry load of paint establishes the feathery edge of the trees against the sky. The structure of the fountain is developed with firm strokes using a no. 10 filbert and the basic form is created with a no. 8 bristle filbert. During the painting a figure came and sat down. The figure, being more organic, and smaller, is painted with a light touch and freer strokes with the no. 8 bristle filbert. The water needs a wet load of light paint; it is applied with the nos. 1 and 8 bristle filbert. A very delicate touch is necessary for this. Any final linear dark or light accents are added with a very wet load of paint using a no. 1 bristle filbert.

THE FOUNTAIN VISITOR • OIL • 60 MINUTES • 18" x 14" (46CM x 36CM)

Creating Bold Brushwork

A snowy scene can be a great opportunity to showcase bold powerful strokes. This is particularly so when using a strong graphic composition. The basic concept is to work from larger simple areas to smaller more intricate ones. It is important to mix a good amount of warm white with some medium.

Materials List

Paints

Alizarin Crimson • Burnt Umber • Cadmium Red Light • Cadmium Yellow Light • Cerulean Blue • Sap Green (Hooker's Green for acrylics) • Terra Rosa (Red Oxide for acrylics) • Titanium White (a soft formula for oils, Gesso for acrylics) • Ultramarine Blue • Viridian • Yellow Ochre

Brushes

Nos. 1, 2, 4, 6, 8, 10 and 12 hog bristle filberts • Nos. 4, 6, 8, 10 and 12 hog bristle flats • Large sable flat for oils • Large 2- to 3-inch (51mm–76mm) flat for acrylics

Mediums

Liquin for oils • Water for acrylics

Other

12" x 16" (30cm x 41cm) Masonite or canvas • Container—a plastic bucket for acrylics or a silicon jar for oils • Palette • Palette knife • Timer

[**STEP 1**] On a 12" x 16" (30cm x 41cm) light colored neutral toned canvas, use a no. 1 bristle filbert to quickly sketch the basic shapes to make the composition. Use a no. 12 bristle flat to create the various drab olives by using a little Liquin combined with blues, ochres and browns, which are similar in the pond and the trees at the top. Be bold with this beginning. A darker brown tree trunk accentuates the top left. This creates the graphic composition.

15 MINUTES

[**STEP 2**] Paint the cool blue-violet shadows on the snow using a no. 8 bristle filbert and a mixture of white, Ultramarine Blue and a touch of Alizarin Crimson. Rock forms and reflections are laid in next with the same brush and warmer tones of ochres, earth tone and white. All should be applied boldly in a somewhat loose abstract manner.

15 MINUTES

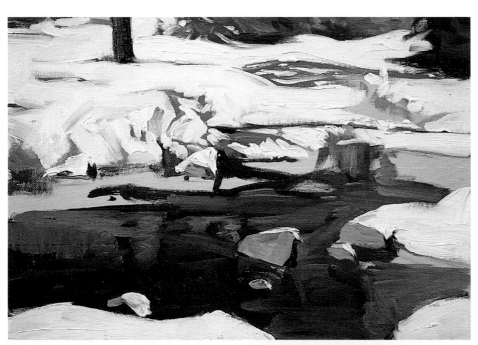

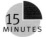
[**STEP 3**] Now concentrate on the sunlit, rich white snow. Use a palette knife to mix a large amount of white, add a little Yellow Ochre for warmth and some medium for fluidity. Apply this boldly with a no. 8 bristle filbert. Add a bit of darker edge control in the trees, some snow on branches and rocks, and a few refinements in the reflections with the no. 8 bristle filbert.

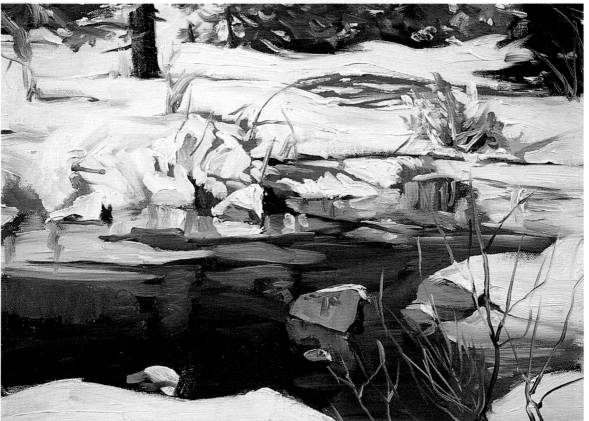

[**STEP 4**] Use the nos. 1 and 8 bristle filberts to begin adding in the warmer more calligraphic weeds, brush and their reflections. Add tree branches, a background, trunks and linear weed forms and branches with the no. 4 round sable using neutral tones of very wet paint. A very light touch must be used when painting through the wet paint, and you must constantly clean the brush.

THE SNOWY TRUCKEE • OIL • 60 MINUTES • 12" x 16" (30CM x 41CM)

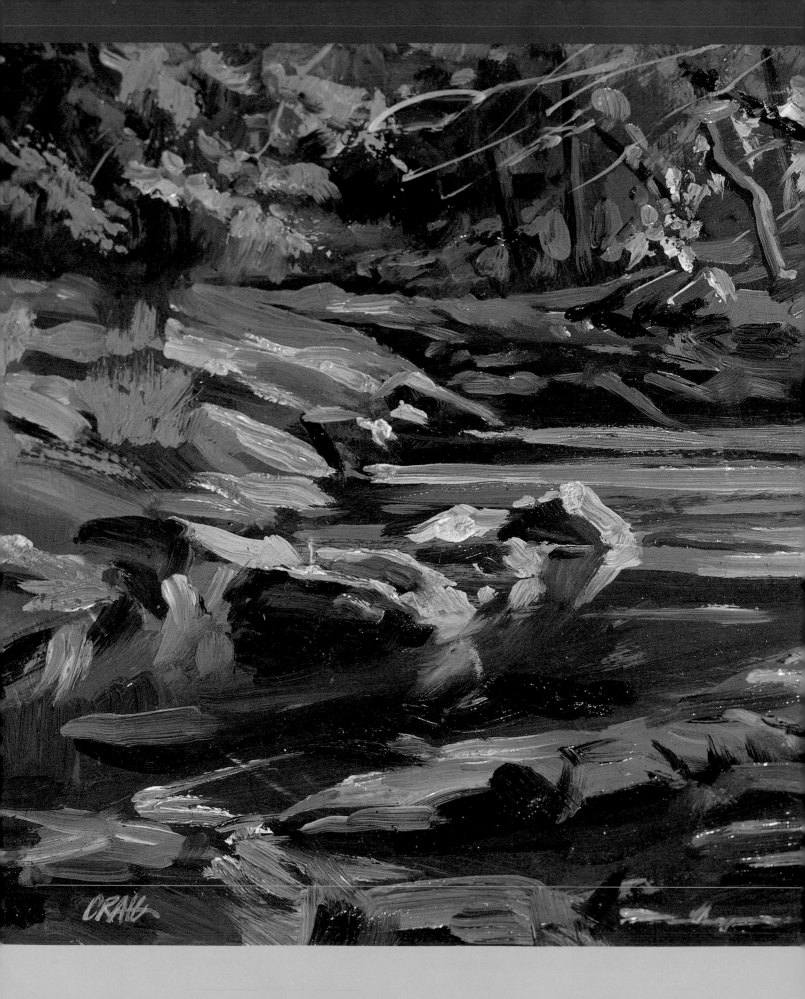

Exploring Various Subjects

New and varied subjects make for exciting studies. A painter may explore an untried subject matter and discover a whole new motif for a series of paintings. New subjects also offer the challenge of painting something new without the investment of a lot of time. Although the subject that you choose to paint is important, always keep in mind that the quality of the painting is also crucial. A painting or study should not only be about the subject but also about how well it is painted.

Paint Quickly in Changing Light
This study was done in Atlanta while fighting mosquitos at about six-thirty in the evening. Light was streaming through and changing fast. I set up all the shadows and background grayer tones, and used bold expressive brushwork to emphasize the light during the last 15 minutes.

SPRING CREEK • OIL • 45 MINUTES • 8" x 10" (20CM x 25CM)

Still Lifes

Still lifes are always great subjects and are easily accessible. Although most people think of still lifes as a floral arrangement or a bowl of fruit, try some other less obvious subjects when painting a still life.

Create Contrast
This combination of candies goes together in terms of subject matter, but the complexity of the forms creates contrast.

BUBBLE GUM AND CHOCOLATE • OIL • 45 MINUTES • 14" x 11" (36CM x 28CM)

Capture Spontaneity
This old suitcase with some clothes hanging out makes a very different kind of still life capturing a spontaneous moment.

NOT PACKED YET • OIL • 45 MINUTES • 14" x 11" (36CM x 28CM)

Trees and Foliage

Trees have a unique quality all their own. The complexity of the edges of the foliage offers a lot of brushwork possibilities, as do the negative spaces between the clusters of leaves and branches. With this in mind, a mixture of large and small brushes works the best.

Create Contrast

As in *November Sun,* a larger brush is best for developing the foliage, constantly varying the greens from olives to ochres to oranges in order to capture the impression of changing leaves. The background shadows were indicated first to give a value to contrast against the lights of the trees. Note the loose (free) brushwork in the foliage and the firm brushwork in the branches and shadows.

AFTERNOON SHADOWS • OIL • 45 MINUTES • 8" x 12" (20CM x 30CM)

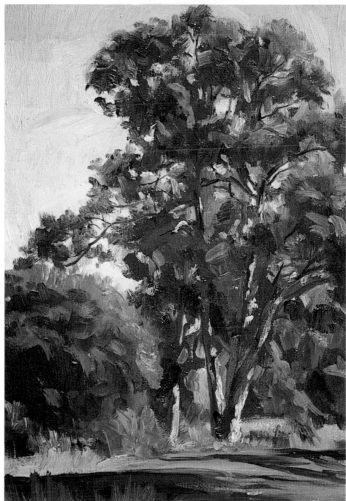

The Relationship Between Sky and Trees

Tree and sky value relationships are very important here. How they meet creates the impression of the elusive edges of the foliage. Larger brushes, nos. 10 and 12, work well for this as a light touch on the brush gives a gentle edge (not firm). To counteract this, a smaller brush such as a no. 2 bristle filbert works well for the trunks, branches and negative sky spaces.

NOVEMBER SUN • OIL • 45 MINUTES • 12" x 8" (30CM x 20CM)

Water

Water comes in various forms: still water, giving a mirrorlike reflection, active water, giving a variety of colors and values, or running water, giving a direction to it. Water is generally fun to paint and gives the painter a way to use a lot of freedom and abstraction in a realistic form of painting. You should try to paint all types of water, simplifying what you see, keeping it looser than the rest of your subject matter.

Simplify Moving Water

When painting a subject this active, you must first analyze it into a simple statement. This is basically a slightly gray-blue-green water mass and a simple warm light and dark shadow rock mass. Only then can you begin to look at the variety of warms and greens in the water, and actively paint them in using a no. 10 bristle flat. Look for the feeling of the activity. Keep perspective in mind—larger strokes up front, smaller strokes in the back. Finish with the same no. 10 flat, mixing up a warm off-white using a touch of Yellow Ochre and some medium to loosen up the paint. Use your arm freely to paint the activity of the white water.

PIERCING THE PACIFIC • OIL • 60 MINUTES • 11" x 14" (28CM x 36CM)

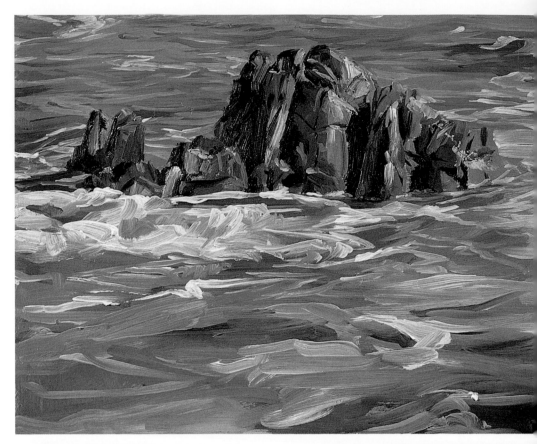

Find the Correct Color and Value

This stream had an active area as it came over the rocks and a quiet area up front. It pierced the landscape beautifully. After blocking in the landscape with nos. 8 and 10 bristle filberts, it is important to get the water's colors and values correct. Looking through the still water, you will see warmer dark olives and some of the landscape colors reflected. The water in the background reflects the blue of the sky. Lastly the little rapids are added with some off whites and a no. 2 bristle filbert.

A QUIET STREAM • OIL • 40 MINUTES • 11" x 14" (28CM x 36CM)

Involved Landscape Scenes

When combining fields, trees, hills and architecture, you must employ various effects as well as create a pleasing composition when setting up the design. It is very important to be aware of all of the various elements in a scenic composition and understand their differences and individual characteristics.

A Bold Landscape

Atmospheric conditions are often an integral part of landscape painting. Fog and mist are effects that may be crucial to depict a given scene. It is great practice to paint in various weather conditions, not only on beautiful sunny days. As the fog here begins to lift, it reveals much of the landscape in sunlight showing greater contrast and stronger color.

THE FOG LEAVES TOMALES • OIL • 50 MINUTES
12" x 18" (30CM x 46CM)

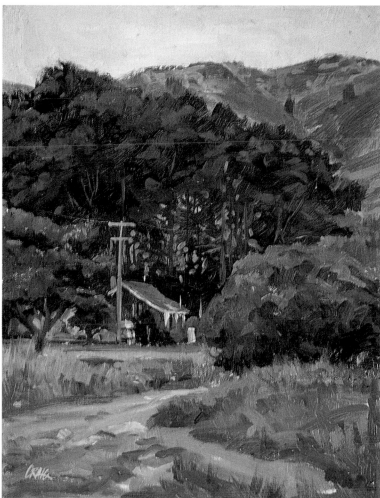

Keep Your Thinking Organized

It is crucial in a complex landscape painting to keep your thinking organized. Begin from the background working toward the foreground. In this painting the focal point is the house in the middle ground. The background hills should be painted with cool pale tones to keep them receding into the background. The foreground has the most color but is painted more loosely and abstractly. The road leads to the focal point which is framed by the grove of trees behind and trees to the right and left. Finally, some small firm controlling strokes finish up the house.

LEAVING MUIR BEACH • OIL • 60 MINUTES •
14" x 11" (36CM x 28CM)

Architecture

Using architecture in a finished painting or study offers a more solid and substantial subject. Intimate views as well as panoramic views are nice variations when dealing with architectural subject matter.

Painting Perspective

This intimate view of Carmel Mission is an example of simple one-point perspective, with all horizontal lines converging to one common point (this helps simplify the drawing). The majority of the composition is in shadow, therefore all of this was painted first in unifying cool tones. After observing the color variations in the weathered walls, they can be added. Finish work is done with a no. 8 bristle filbert for the lights and a no. 2 bristle filbert for a few linear details.

MISSION CORRIDOR • OIL • 50 MINUTES • 11" x 14" (28CM x 36CM)

Architecture Contrasts With Organic Forms

This old house was intriguing—set off the road and almost hidden behind some trees. When architecture is included in a landscape, it will always stand out because of its contrasting solid blocklike form set against the free organic forms of the landscape.

BEYOND THE CYCLONE FENCE • OIL • 60 MINUTES • 12" x 16" (30CM x 41CM) • COLLECTION OF PO PIN LIN

Boats

Boats, like architecture, are generally bold blocky forms with linear or calligraphic accents on top. Being set in a watery surrounding adds further character variation to any boat study. All types of boats, from rowboats to huge fishing trawlers, are great subjects to try.

Painting a Mist-Filled Day

The dark warm shape of the old boat stands out beautifully against the sunny, mist-filled background. The wind kept the water so chopped up that it basically glistened white. This is where painting experience helps; keeping the water very light, as it appeared, I added a soft blue-green tone to it and a faint, loose, slightly warm reflection, all with a no. 10 bristle flat. The boat itself is painted with the same no. 10 in the block-in stage and finished with a no. 6 bristle filbert and a no. 1 filbert (in the linear areas of the A-frame structure).

THE OLD BOAT IN TOMALES BAY • OIL • 50 MINUTES • 14" x 11" (36CM x 28CM)

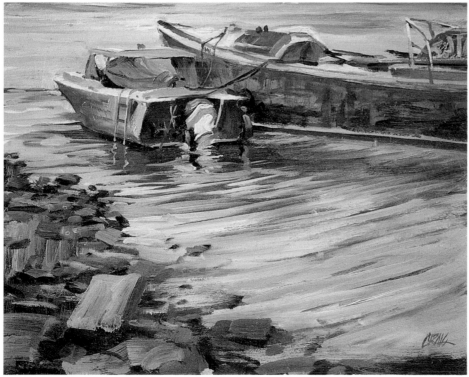

Creating Interesting Compositions

Two boats sitting in a canal make a nice intimate staging. The abstraction of the water and the foreground rocks are a great contrast for the focal point of the boats. Firm deliberate strokes help establish the solidity of the boat forms.

WATER PARTNERS • OIL • 45 MINUTES • 11" x 14" (28CM x 36CM)

Interiors

Interiors cover an enormous range of possibilities. They usually employ some of the subjects previously discussed. Architecture and still life subjects are included in the form of chairs, tables, doors, walls and windows. Figures may punctuate an interior to give a possible narrative content. From cafes to markets to the simple corner of a room, doing a quick study of an interior is a complex undertaking. However, by keeping the process simple and building the complexity in the proper stages, it is possible to convey a complicated interior as well as a simple one.

Unify the Dark Shapes
Once again perspective is important. However, the breakup of space in this complex composition must be approached with the unifying dark shapes. The warm tent top and the bright lights are the next components to focus on. Smaller light- and dark-colored accents finish the study. Once again the painting is started with a no. 10 bristle filbert and finished with a no. 2 bristle filbert.

FISH MARKET • OIL • 60 MINUTES • 11" x 14" (28CM x 36CM)

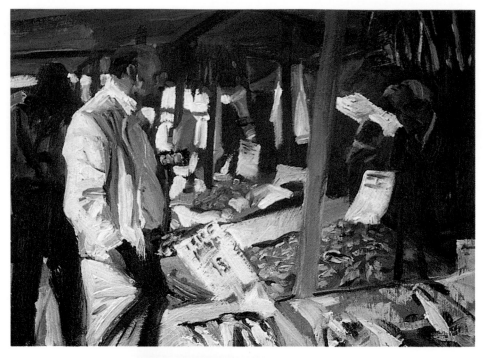

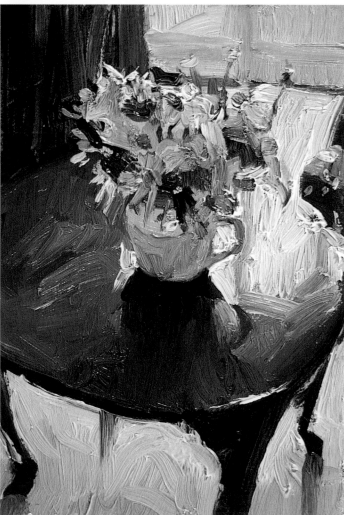

Two Brushes Make Quick Work
This quick little study is painted with two brushes: nos. 2 and 8 bristle filberts. It is a backlit composition; therefore, everything is painted with shadow tones in mind. The finished lights are painted with the no. 2 and a fair amount of white paint applied in the impasto style.

COLOR ON THE TABLE • OIL • 25 MINUTES • 7" x 5" (18CM x 13CM)

Animals

Wildlife painting is a popular and enjoyable endeavor. Perhaps what makes this so is the search for the subject matter. It's great fun to go on photo safaris in the mountains, national parks or even on farms. Searching in the appropriate environment enriches the entire experience and gives great conviction to the study.

Accenting With Hue and Value

The large bold shapes are accented with bits of color and a few lights. This is exactly how this should be painted. Quickly indicate the simplicity of the background. Work in the two large dark masses of the rooster—cool dark on top and warm dark on the bottom—with the no. 10 flat. Use the large brush for the majority of the more colorful feathers, painting with a light touch. Switch to the nos. 2 and 8 bristle filberts or flats for the bright smaller accents in the head and feathers. A palette knife adds a little texture to the ground plane.

KING OF THE BARNYARD • OIL • 50 MINUTES • 11" x 14" (28CM x 36CM)

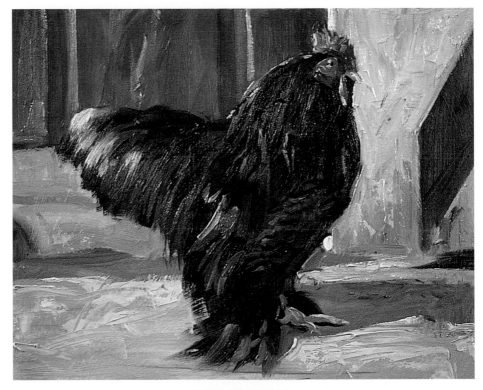

Creating Interesting Contrast

The terrain plays an important supportive role in which to stage the elk. There is an appealing contrast between the more colorful greens and oranges of the landscape and the violets and warm darks of the elk. The key to this is simple. Complete the initial sketch, then set the stage for the animals with a simple bold approach of close various green values and soft warms in the terrain. Switch to smaller (nos. 2 and 8) bristle flats for the elk, and finish with the bright light backlighting. A small palette knife can be used in the foreground to scrape on some textural variations.

TULE ELK • OIL • 45 MINUTES • 11" x 14" (28CM x 36CM)

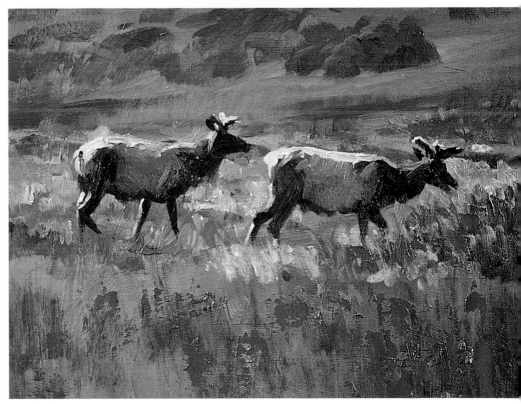

The Figure in an Environment

In a painting where the figure and environment truly complement each other, it is crucial to quickly analyze the elements to be painted. Shapes, values, colors and edges all play important parts in the overall success of the study. What needs to be simplified or understated, and what needs to be clarified or refined must be understood. If you do not analyze the subject first, the complexity may overwhelm you. In most cases, the environment supports the figure; therefore it may be abbreviated, leaving the emphasis on the figure.

Materials List

Paints

Alizarin Crimson • Burnt Umber • Cadmium Red Light • Cadmium Yellow Light • Cerulean Blue • Sap Green (Hooker's Green for acrylics) • Terra Rosa (Red Oxide for acrylics) • Titanium White (a soft formula for oils, Gesso for acrylics) • Ultramarine Blue • Viridian • Yellow Ochre

Brushes

Nos. 1, 2, 4, 6, 8, 10 and 12 hog bristle filberts • Nos. 4, 6, 8, 10 and 12 hog bristle flats • Large sable flat for oils • Large 2- to 3-inch (51mm–76mm) flat for acrylics

Mediums

Liquin for oils • Water for acrylics

Other

12" x 16" (30cm x 41cm) Masonite or canvas • Container—a plastic bucket for acrylics or a silicon jar for oils • Palette • Palette knife • Timer

[**STEP 1**] Use a no. 1 bristle filbert to sketch a quick (3-minute) compositional drawing on a 12" x 16" (30cm x 41cm) light neutral toned Masonite panel. Use a no. 10 bristle flat to paint olive browns and warm dark combinations of Ultramarine Blue and Burnt Umber to lay in variations of deep shadows. Warm the shadows of the flesh and hair with a bit of Terra Rosa.

[**STEP 2**] Continue to set the stage for the figure study. Vary the warm and cool light grays in the rocks with loosely indicated strokes using a no. 10 bristle flat. Add a few lighter color variations in the water.

Turn your attention to the figure. The two areas to concentrate on are the shadow of the dress and the warm lights of the flesh. Check the values carefully and lay them in with a bit more care using a no. 8 bristle filbert.

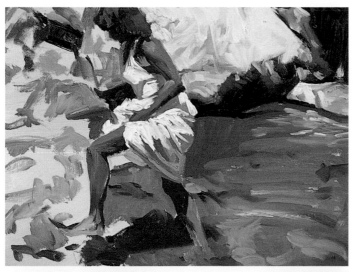

[STEP 3] Return to the back-ground and work on some of the more subtle lights on the rock forms and value transitions from light to shadow. Pick up more color and activity in the water. All of this is done with the no. 10 filbert bristle.

Back to the figure: Use the no. 8 bristle filbert to add some lighter warmth to the light side of the hair, and a few subtle lights to the flesh structure. Begin to refine the action and folds in the dress with a warm white (white with Yellow Ochre) with the no. 8.

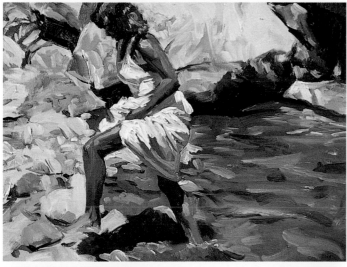

[STEP 4] Add a few warm spots to the rocks and some fur-ther refinement in the lights with a no. 8 bristle flat. More light variations should be added in the water and around the feet to indicate the disturbance to the water caused by the figure. The addition of more light tones within the anatomy of the figure will further emphasize the structure, and some lighter highlights in the hair will add a bit more sheen.

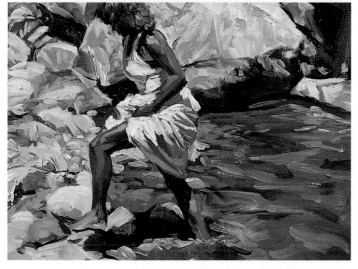

[STEP 5] The study is basically done. Add a few accents to give a further sense of completion. Add a few darker shapes in the rocks with a no. 2 bristle filbert, and a little more light splash by the figure's feet. Add some reflected light and color into the shadow of the light fabric. Finally, add some subtle warm reflected light in the face.

COLD MOUNTAIN STREAM • OIL • 60 MINUTES • 12" x 16" (30CM x 41CM)

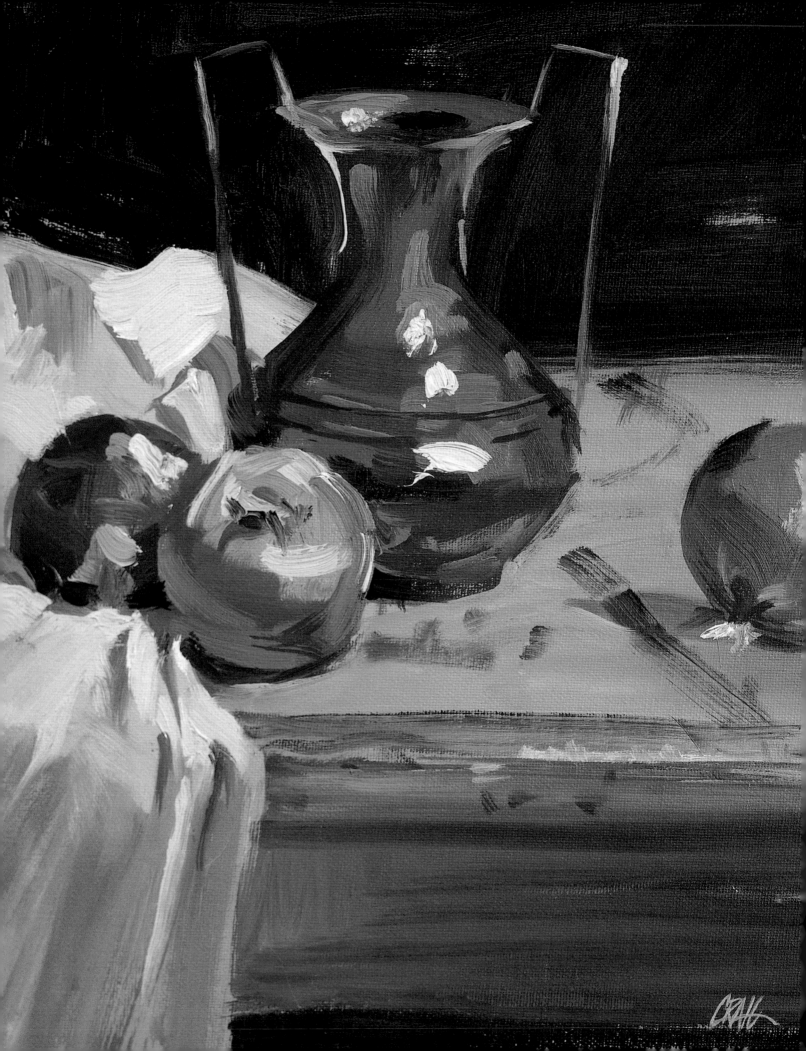

Exploring Various Compositions

Composition is such an important aspect to any painting that devoting only one chapter to it is, perhaps, an injustice. It is the composition or design of a painting that first captures the viewer's attention. Studies have always been a source of compositional exploration. Once again, a quick study will allow the painter to try various compositions of any given subject without the investment of a great deal of time.

It is not unusual for a painter to fall into a comfortable routine in dealing with composition. There are many varied possibilities when composing a picture utilizing concepts such as object placement, cropping, spatial breakup and point of view, to name a few. A quick study allows the painter to view these as artistic statements, not just fleeting thoughts.

A Formal Composition
Although the objects seem to be casually placed, the central anchor of the composition is the brown metallic vase. The weight of the two onions on the left is counterbalanced by pushing away the onion on the right and cropping it to benefit and balance the composition.

UNTIDY TABLE • OIL • 40 MINUTES • 16" X 12" (41CM X 30CM)

CHAPTER 6

Formal Composition vs. Informal Composition

An informal composition differs from the formal composition in the placement of the subject matter. The symmetrical, or centered, placement of the subject within the formal composition is contrasted by the asymmetrical, or off-centered, placement of the subject in the informal composition, giving two entirely different compositional appearances.

Formal Composition
This is a classic symmetrical centered formal composition. Not only is the gull centered, but also it is atop a classic triangle created by the rock forms.

ALONE • OIL • 25 MINUTES • 7" X 5" (18CM X 13CM)

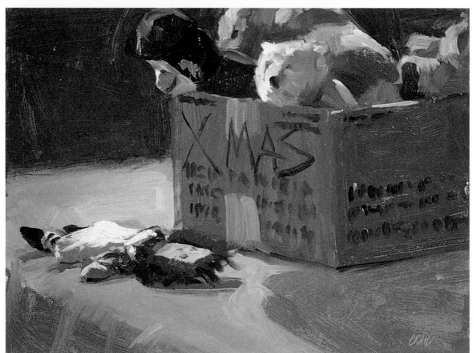

Informal Composition
By pushing off the box of stuffed animals to the side, it enables the viewer to focus on the simple rag doll. This creates an asymmetrical or off-centered composition, which contributes to the tossed-out concept, and gives a more interesting breakup of space.

MEMBERS ONLY • OIL • 45 MINUTES • 11" X 14" (28CM X 36CM)

Chaotic and Casual Compositions

Generally most compositions fall into some sort of an orderly structure. Arrangements of subjects, which are random and seemingly disorderly, may appear more casual or chaotic. These usually consist of several elements placed in a more or less casual manner—as if things were just left around, or just happened—giving a more scattered effect.

Casual Composition
The stack of casually placed books along with the old coffeepot, lemon and mug, appear as if they have been set down with no particular order or reason.

BOOKS AND STUFF • OIL • 45 MINUTES • 11" x 14" (28CM x 36CM)

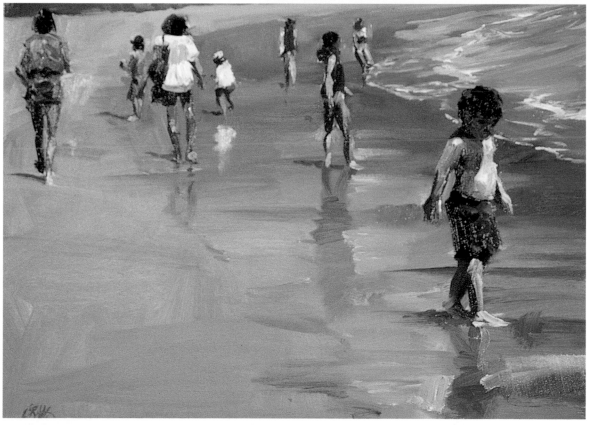

Chaotic Composition
The random and spotty arrangement of the people on the beach gives a chaotic quality to the painting. This is heightened by the various directions that the figures are facing. It all creates an unstructured movement to the painting, which is the sense that one gets while gazing down a public beach.

BEACH FOLK • OIL • 60 MINUTES • 12" x 16" (30CM x 41CM)

Exploring Cropping

In reality, as we view any given subject, there is no definite edge where our vision stops; our focus trails off into our peripheral vision on the edges. Therefore, in a painting an artist must crop the subject matter in order for it to fit on the rectangular canvas. It is that choice of the cropping that becomes an aesthetic consideration. It may be very interesting to attempt an unorthodox cropping for a provocative image. Once again, the quick study is a perfect vehicle for exploring various croppings for composition.

Cropping the Subject Matter

The formal approach to this composition takes a unique turn using cropping. The primary subject matter is given a very small area at the top of the picture. Instead of showing the complete subject, the top third of the bottle is cropped. This helps create a bit of interest through the tension of the unexpected cropping. And it shows how cropping may contribute to the break up of space.

TINY TABLE TOP • OIL • 35 MINUTES • 14" x 11" (36CM x 28CM)

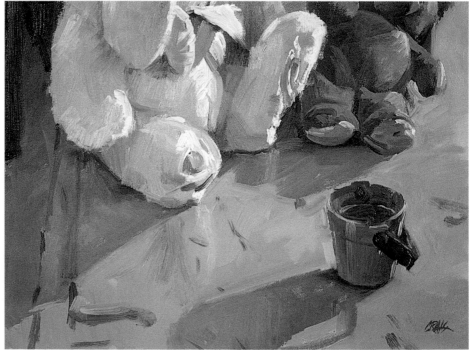

Focusing on the Subject

In this composition, an informal arrangement is used. Choosing to crop off the top half of the two stuffed animals leaves only the green bucket totally within the picture plane. This not only gives a clear focus on the bucket, but also adds a bit of intrigue.

LITTLE GREEN BUCKET • OIL • 45 MINUTES • 12" x 16" (30CM x 41CM)

Points of View

The point of view that an artist chooses to paint plays a great role in the overall composition of a painting. Looking up as a worm's-eye view, looking down as a bird's-eye view, viewing from a distance as a panoramic view, or viewing up close as an intimate point of view, are all choices that every painter must consider. Other points of view are possible, such as looking out from behind a tree, post or wall, and finding obvious foreground and background elements.

The Bird's-Eye View
An intimate point of view, combined with a slight bird's-eye view gives this casual still life a nice flow to the objects. A lower point of view would not allow the pieces of candy to move across the picture, directing the viewer's eye around the composition.

A GLASS OF CANDY • OIL • 35 MINUTES • 11" x 14" (28CM x 36CM)

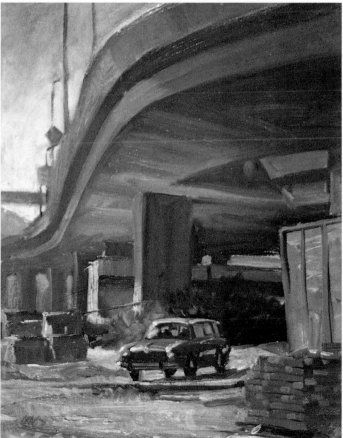

The Worm's-Eye View
Instead of focusing tightly on the red vehicle, I stood at a greater distance and focused upward at the freeway overhead; a more dynamic composition was achieved. This allows for a more intriguing breakup of space that deals with angles, perspective and the interesting overlap of elements to create a much more captivating picture.

BENEATH THE OLD 280 II • OIL • 60 MINUTES • 14" x 11" (36CM x 28CM)

Breaking Up Graphic Space

Breaking up the graphic space within the picture plane is one of the predominant design considerations in any composition. Placing something in the center of a painting creates a targetlike composition. For more dynamics within the composition, an uneven spatial breakup is often much more interesting. A larger simple space may be complemented by a small active or colorful space, thus playing one against the other.

The Creative Breakup of Space

Three basic elements make up this composition; the rocky cliffs, the foliage and the sky. All three occupy vastly different amounts of space. Over three-quarters of the painting is taken up by the shadowy rocks, while the remainder of the space is dominated by the sky, with the foliage and tree breaking in and receiving a bit of afternoon sun. This demonstrates a strong uneven graphic breakup of space, and a more unusual and provocative composition.

IN THE SHADOWS • OIL • 60 MINUTES • 14" X 18" (36CM X 46CM)

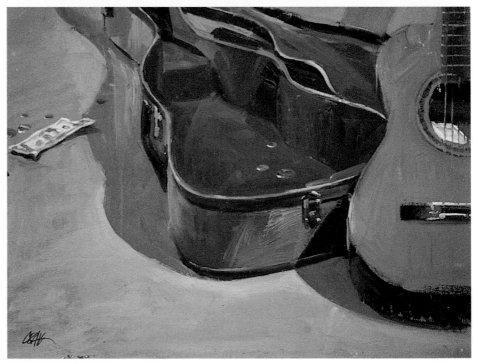

Breaking Up of Graphic Space

The picture plane is graphically one dimensional; breaking it up graphically is one way of approaching a compositional design. Here a closely cropped guitar and case break up the ground space with large bold shapes. This utilizes curved, straight and diagonal lines to overlap the flat ground plane.

MUSIC MONEY • OIL • 40 MINUTES • 12" x 16" (30CM X 41CM)

Compositional Clues

Understanding and mastering composition is easy when you simplify the elements. Use these diagrams to help you create interesting compositions.

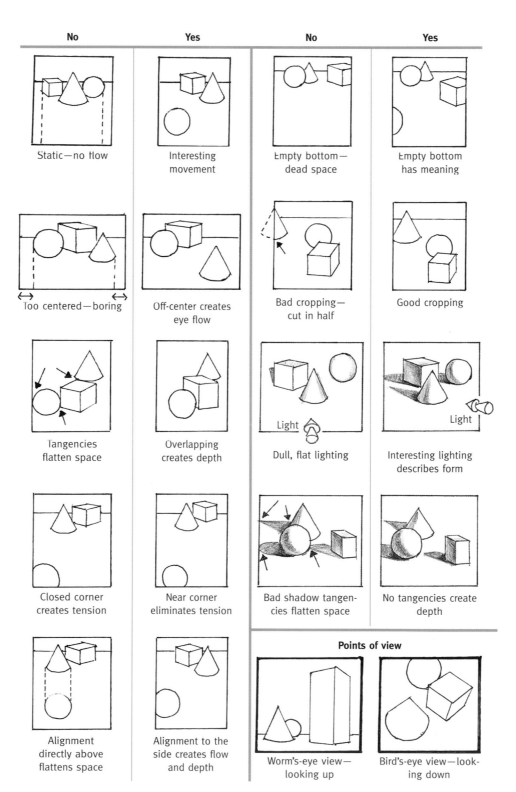

No	Yes	No	Yes
Static—no flow	Interesting movement	Empty bottom— dead space	Empty bottom has meaning
Too centered—boring	Off-center creates eye flow	Bad cropping— cut in half	Good cropping
Tangencies flatten space	Overlapping creates depth	Dull, flat lighting	Interesting lighting describes form
Closed corner creates tension	Near corner eliminates tension	Bad shadow tangencies flatten space	No tangencies create depth
Alignment directly above flattens space	Alignment to the side creates flow and depth		

Points of view

Worm's-eye view— looking up

Bird's-eye view—looking down

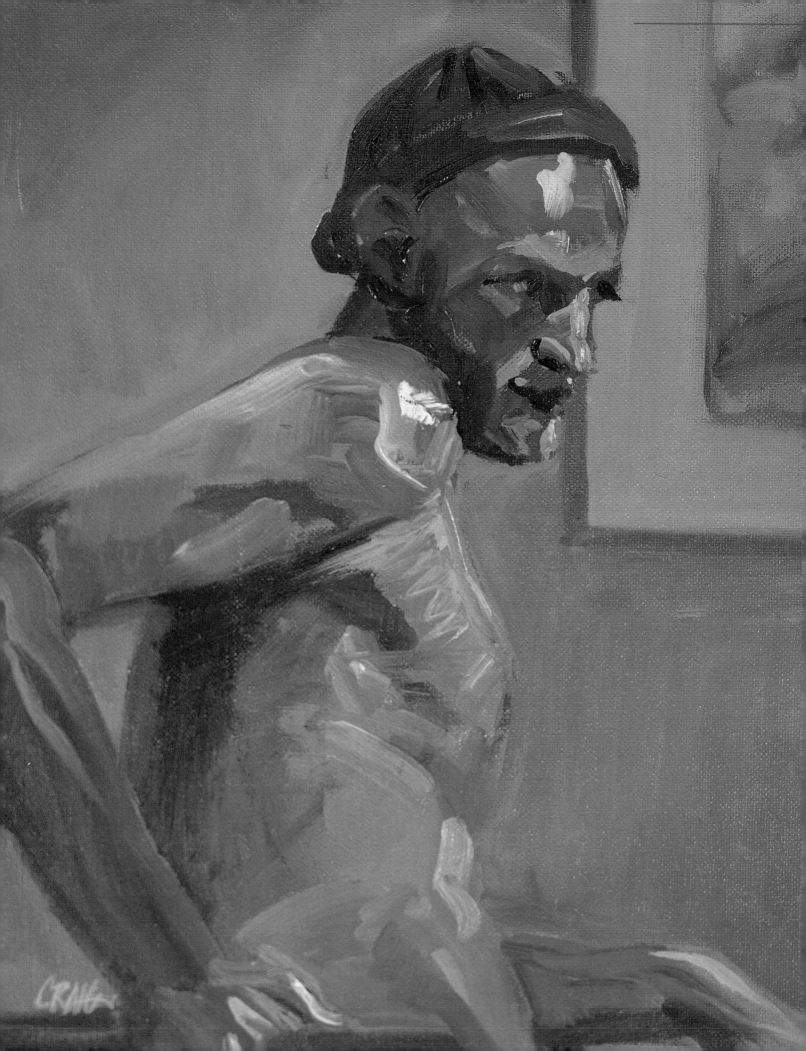

Color

Color for many painters is the dominant consideration in the creation of their painting. It is color that gives spice to a painting. Appropriate color usage can liven up a painting or mellow it out. A chef has an array of spices to choose from and combine. A painter has a palette of various colors to choose from and combine that may enhance the subject and the composition. Color may affect the mood of a subject. It can bring out or subdue a passage in any given picture.

As a painter considers a color choice they must consider the three properties of color: hue, value and intensity. *Hue* is the basic chroma of a color—red, yellow, blue, green, etc. *Value* is the lightness or darkness of a color—where the color falls on a gray scale. And *intensity* is the brightness or strength of a color—how pure or muted it is. There are endless possibilities when combining these variables. Mastering these elements is difficult, fascinating and a lifelong challenge.

Shadows Affect Color Temperature
The temperature variations are partly due to warm lights and cool shadows. The greens are influenced by reflective color. Note the warmer and darker forearms caused by sun and more bone and muscle. Warm lights are also reflected onto the face.

THE RED CAP • OIL • 40 MINUTES • 14" x 11" (36CM x 28CM)

The Full Palette

A full palette includes all three of the primary hues—red, yellow and blue—in their full intensity. In this case, the full palette consisted of Titanium White, Cadmium Yellow Light, Yellow Ochre, Cadmium Red Light, Alizarin Crimson, Ultramarine Blue, Cerulean Blue, Terra Rosa and Burnt Umber (for its darkness). A full palette may be used to produce richly intense paintings as well as subtle grayer paintings. Remember: color is always about relationships, grays vs. intensities, warms vs. cools, darks vs. lights.

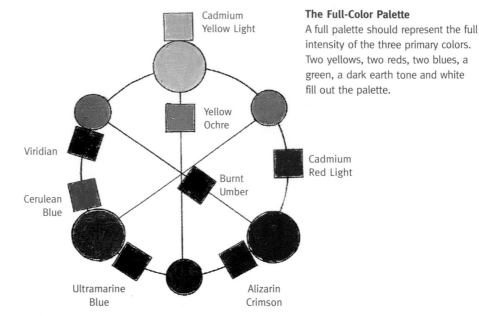

The Full-Color Palette
A full palette should represent the full intensity of the three primary colors. Two yellows, two reds, two blues, a green, a dark earth tone and white fill out the palette.

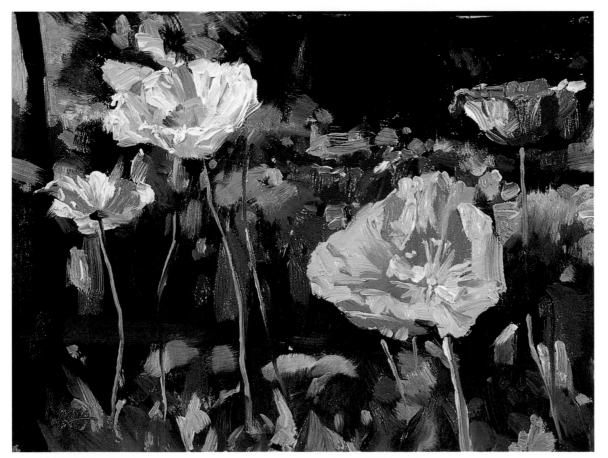

Using the Full Palette
A powerful amount of intensity is set off by the deep dark background tone. This enables the color strength of each flower to jump out at the viewer. The color concept is basically light and bright set off by dark and dull. Only a full-color palette could have achieved this at maximum intensity.

INTENSE STATEMENT • OIL • 55 MINUTES • 9" x 12" (23CM x 30CM)

The Limited Palette

A wonderful limited palette is a muted version of the color wheel replacing red with Terra Rosa, yellow with Yellow Ochre and blue with gray (Ivory Black combined with Titanium White). It is the relationships between the colors that create a feeling of full color.

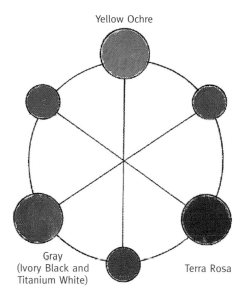

Yellow Ochre

Gray
(Ivory Black and
Titanium White)

Terra Rosa

The Limited Palette
I recommend using a limited palette for beginners. Using the limited palette will help you understand hue, value and intensity.

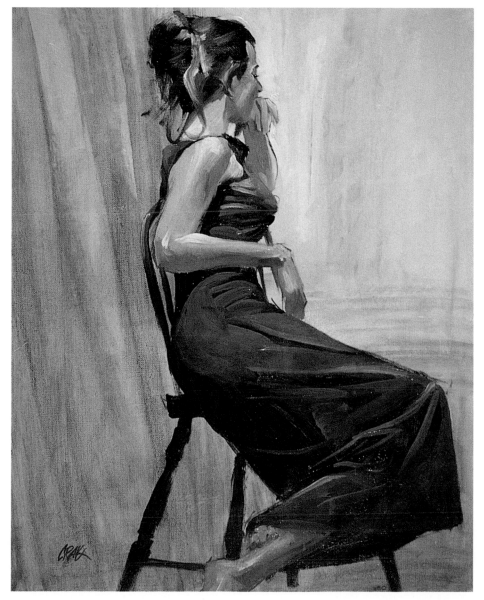

Using the Limited Palette
This was truly a great pose. A background tone of Titanium White, a little Yellow Ochre and a slight amount of Ivory Black was dry before the painting was done. Having only four colors to choose from made the unified, grayed color harmony easy to achieve; first thinking value, then hue and finally intensity.

CLASSY ATTITUDE • OIL • 40 MINUTES • 30" x 16" (76CM x 41CM)

Analogous Color

Analogous color schemes are colors that are related through one common color. For example a lemon, an orange and a lime all have yellow in common; therefore, they are all in the same color family. Analogous colors can bring color harmony and unity to a painting. A mood may be created through analogous color schemes. A sunset will be influenced by a warm red-orange glow. A still life may be orchestrated towards an analogous scheme simply by choosing objects that are related by color such as a blue-colored vase, violet or fuschia flowers and green grades that are united by the color blue. Rembrandt, for example, often worked in warm earth tones, seldom using a cooler blue or green. In color schemes such as these, no color will jolt the viewer. Complementary colors are only used to gray or mute a color.

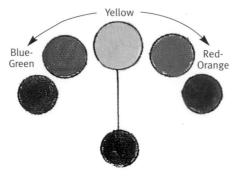

Analogous Color Schemes
Analogous colors can be found adjacent to one another on the color wheel. They are unified by a dominant color, which is yellow in this example.

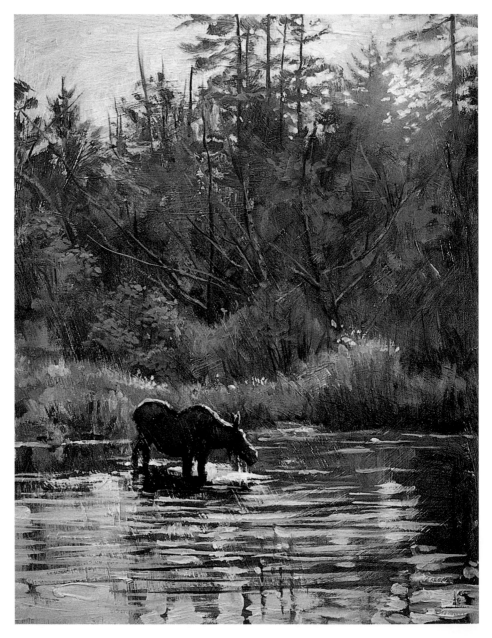

A Yellow Color Scheme
The mother color of yellow unites the various subjects in this painting. The greens of the trees are more dominant than the subtle oranges in the foliage. The variety of color movement is placed in this narrow range, giving a harmony to the painting.

KNEE DEEP • OIL • 60 MINUTES • 18" x 14" (46CM x 36CM)

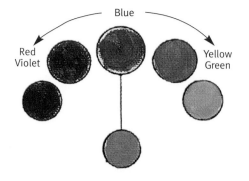

Blue

Red
Violet

Yellow
Green

Analogous Color Schemes
Blue is the dominant color in this palette.

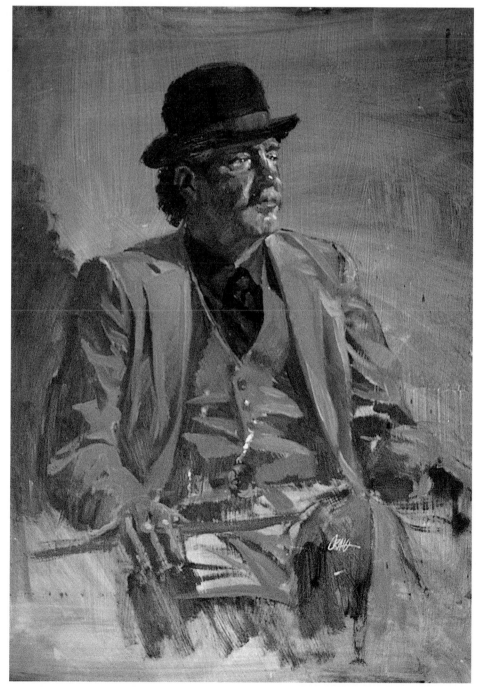

A Blue Color Scheme
A scrubby blue and violet wash sets the tone for the blue-gray suit. In order for the fleshtones to work into the blue scheme, they had to be grayed down into a cooler fleshtone. The only warm is in the tie, where an intense red-violet stripe is used as a somewhat colorful accent.

JOHN'S DERBY • OIL • 60 MINUTES • 24" X
18" (61CM X 46CM)

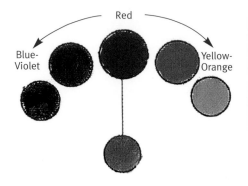

Red

Blue-
Violet

Yellow-
Orange

Analogous Color Schemes
A red analogous color scheme can be used to create an intense feeling of warmth in your painting.

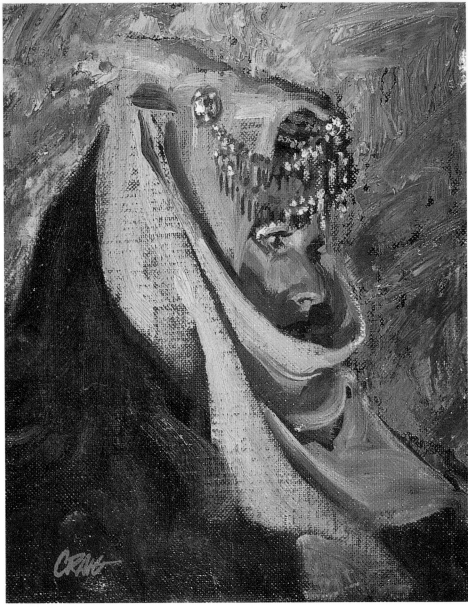

A Red Color Scheme
In this case, the analogous color scheme revolves around red. Subtle oranges and violets keep the analogous flavor of the painting. The coolest color is the head jewelry, using a bit of Yellow Ochre, which leans a little towards green but still has a touch of red in it.

VEILED • OIL • 40 MINUTES • 10" x 8" (25CM x 20CM)

Exaggerated Color

The best practice for studying exaggerated color is to work from the figure. There is a preconceived idea that a fleshtone is equal throughout the body; this is an absolute misconception. Physiology, lighting effects, local color changes, sun exposure and other outside forces play a large roll in color changes in the body. Areas closer to bones and cartilage are generally warmer, as are extremities such as fingers and toes. Softer, fatty areas are generally cooler and lighter.

Working from the figure is a wonderful exercise in observation; look closely and become sensitive to the subtlety of color changes. Once a temperature change (warmer or cooler) is realized, it may be exaggerated or amplified while keeping the value accurate. This sensitivity to subtle color change may then be used on all subjects if so desired.

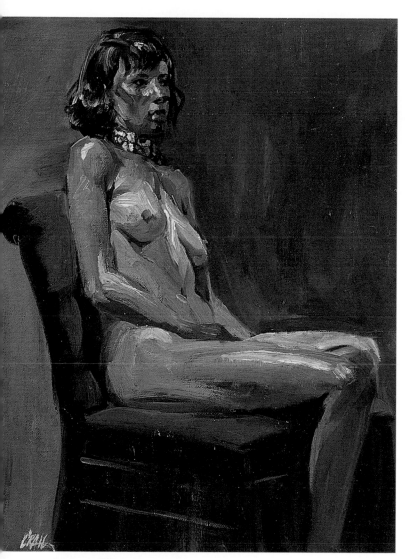

Anatomy Effects Temperature
The physiology of the female figure allows a painter to maximize the temperature and value changes. The boney areas and the exposure to sunlight create the reds. By contrast the breasts, buttocks and the thigh are lighter and cooler because they tend to be less boney and are not exposed to sunlight. A cooler environment influences the cooler shadows. Everything is pushed in color!

SEATED • OIL • 40 MINUTES • 16" x 12" (41CM x 30CM)

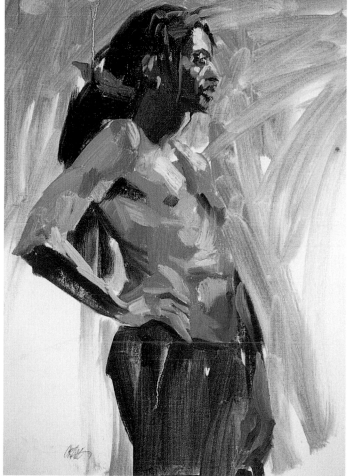

Lighting Affects the Temperature
The temperature change here is primarily due to the lighting, which creates warmer lights and cooler shadows. Wherever a color change is noted, a bold chunky color note is laid in, sculpting the figure with the color and various value changes.

STANDING • OIL • 25 MINUTES • 14" x 11" (36CM x 28CM)

High-Key Color Schemes

Colors, which fall in the lighter half of the value range, are referred to as *high-key* colors. These may give an airy feeling to a picture. High-key paintings can contain a lot of beautiful color variation, since darks usually dull down intensity. Darks rarely are used beyond a 50 percent gray value.

High-key paintings are extremely challenging. They often have a tendency to get chalky or washed out. This is usually due to using too much white, and not finding the color variations from light to shadow and reflected color. Temperature changes play an extremely important role in high-key situations.

High-Key Values
This gray scale shows where the values for a high-key painting would fall on a full range of value. High-key paintings are represented by the light end of the gray scale.

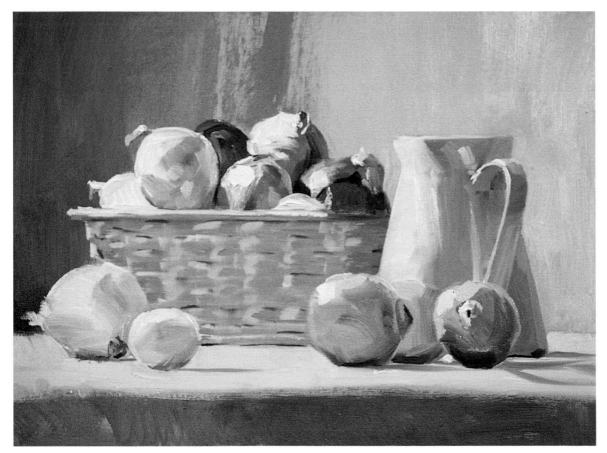

Maintain the High-Key Concept
Still lifes are excellent for doing high-key paintings. Subjects may be chosen for their color variation and light value. A great deal of relatively lighter intense color may be used. Color exaggeration is possible, providing nothing leans too dark. Maintaining the high-key concept is the challenge.

WHITE, LIGHT AND BRIGHT • OIL • 60 MINUTES • 12" x 16" (30CM x 41CM)

Representing Atmosphere

Distant vistas offer an atmospheric high-key quality. The light greens and darker trees are softened through a veil of moisture in the air (often found near the coast). The airy, distant qualities are achieved by gradually adding more white and slight cools as things recede.

SPRING CARPET • OIL • 45 MINUTES • 9" x 12" (23CM x 30CM)

Key Up Dark Elements

A figure dressed in white, or near white, is a great subject for a high-key painting. It is crucial to key up the dark hair, so it is not too dark and doesn't violate the high-key concept. It is, however, the darkest element in the picture. Temperature variations in the whites are accented with various light intensities.

RELAXATION • OIL • 40 MINUTES • 11" x 14" (28CM x 36CM)

Low-Key Color Schemes

High-key color schemes represent the lighter end of the value scale, therefore the darker 50 percent of the value range is considered *low key*. A dimly lit interior, a night scene or a figure in dark clothing or deep shadow can all contribute to a low-key painting. Extremely dramatic lighting may make for a mysterious mood in low-key paintings.

In low-key paintings, it is the light areas that contain the most intense color. The shadows may often dissolve into the near blackness of a background. Analogous or limited palette schemes sometimes work best when attempting a low-key painting, but are not always necessary.

Low-Key Values
This gray scale shows where the values for a low-key painting would fall on a full range of value. Low-key paintings are represented by the dark end of the gray scale.

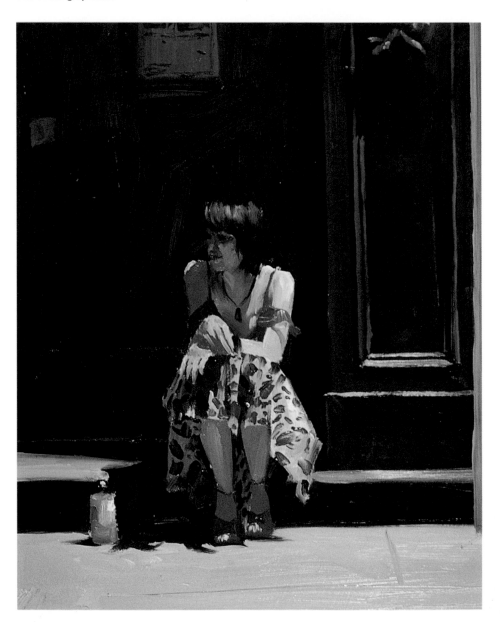

Create a Lost-and-Found Effect
Sitting in a shadowy doorway lends itself to the low-key concept. The figure is almost swallowed by the shadow creating a lost-and-found effect. The lights on the girl are so minimal that they do not overpower the low-key effect of the painting. The darks thoroughly dominate.

SOHO GIRL • OIL • 45 MINUTES • 16" X 12" (41CM X 30CM)

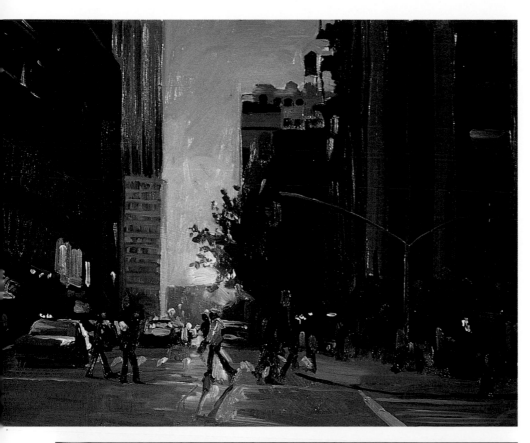

Use Lighter Spots to Create Intensity

The near silhouetting of the New York cityscape in very dark tones is emphasized by the sky and sunset. The architecture is basically painted as a solid shape, with just a slight indication of detail. Any intensity occurs only in the lighter spots, where lights are being illuminated.

THE EAST SIDE • OIL • 60 MINUTES • 11" x 14" (28CM x 36CM)

Keep the Painting Low Key

Dressing a darker-skinned model in dark clothing makes a great low-key subject that can create a provocative image. Keeping everything in the darker value range helps to set off the lighter hat, which slightly violates the low-key concept. This, however, only takes up a small portion of the painting, keeping 90 percent of the painting in the very dark range.

RED SUSPENDERS • OIL • 60 MINUTES • 18" x 24" (46CM x 61CM)

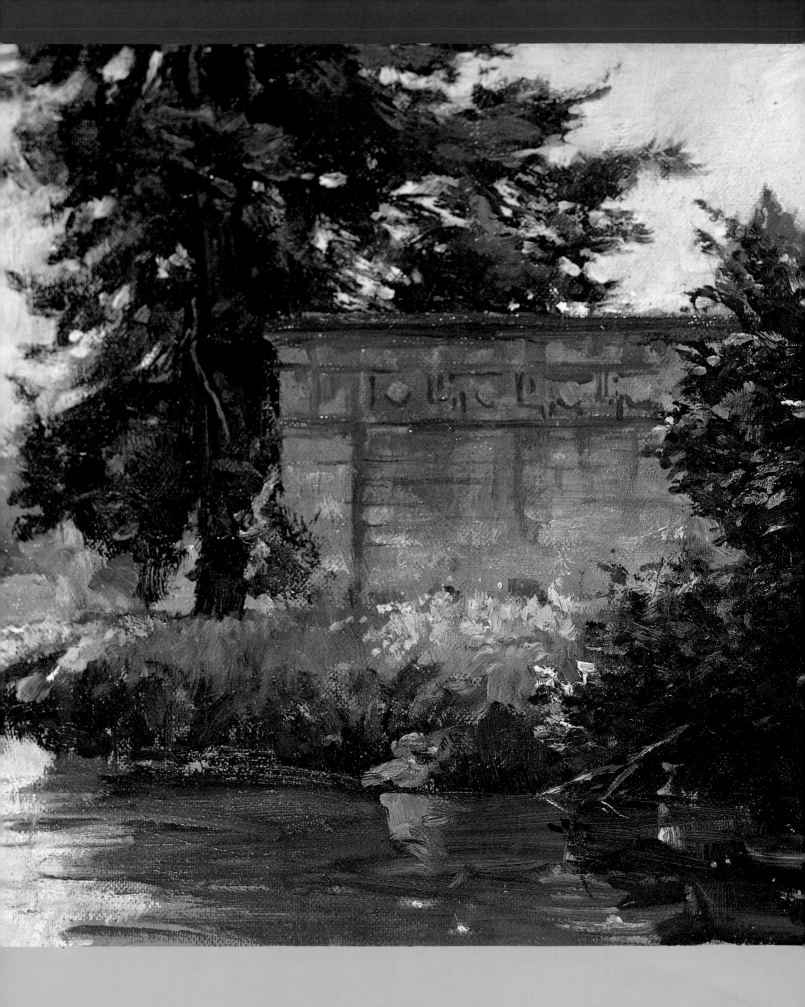

Creating Light Effects

Lighting is a prime ingredient of any painting. Without light we do not see. The lighting of any subject helps to create the mood or impact of a painting. Light effects in landscape painting are controlled by nature, while interior lighting is controlled or set up by the artist. Many painters have developed their overall style through the choice of a light effect that they found particularly interesting.

Flat Lighting

The strong design of this painting is determined through the use of the *flat light* effect. The overcast day gives a gray light, with the overall light effect coming from above. This allows the shapes of the elements to dominate, and the subtle top lighting to support the design.

THE PALACE WALL • OIL • 50 MINUTES • 11" x 14" (28CM x 36CM)

Flat Lighting—Overall Interior Light

The term *flat lighting* refers to overall lighting as opposed to a single, strong, obvious light source. Two of the most common forms of this are an overcast or gray day when painting on location, and an overall ambient lighting found in interiors. When this flat light is in effect, it is the pattern and local color of shapes that dominate; the light that depicts form is subordinate.

Materials List

Paints

Alizarin Crimson · Burnt Umber · Cadmium Red Light · Cadmium Yellow Light · Cerulean Blue · Sap Green (Hooker's Green for acrylics) · Terra Rosa (Red Oxide for acrylics) · Titanium White (a soft formula for oils, Gesso for acrylics) · Ultramarine Blue · Viridian · Yellow Ochre

Brushes

Nos. 1, 2, 4, 6, 8, 10 and 12 hog bristle filberts · Nos. 4, 6, 8, 10 and 12 hog bristle flats · Large sable flat for oils · Large 2- to 3-inch (51mm–76mm) flat for acrylics

Mediums

Liquin for oils · Water for acrylics

Other

14" x 11" (36cm x 28cm) Masonite or canvas · Container—a plastic bucket for acrylics or a silicon jar for oils · Palette · Palette knife · Timer

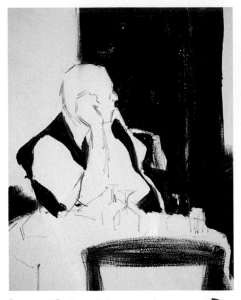

[STEP 1] On a light neutral warm toned Masonite panel, use a no. 2 bristle filbert to lay in an abbreviated proportional sketch using a thin mixture of Burnt Umber and Ultramarine Blue. Use a no. 10 bristle filbert loaded with a thicker version of the same mixture to block in and unify all of the strong dark tones.

10 MINUTES

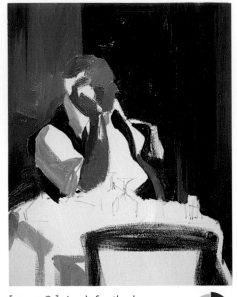

[STEP 2] Look for the large midtone darks (warm brown variations) in the background, the basic fleshtone, the darker whites in the shirt and tablecloth. Boldly paint these with nos. 8 and 10 bristle flats. Add some additional warms in the face for interest.

10 MINUTES

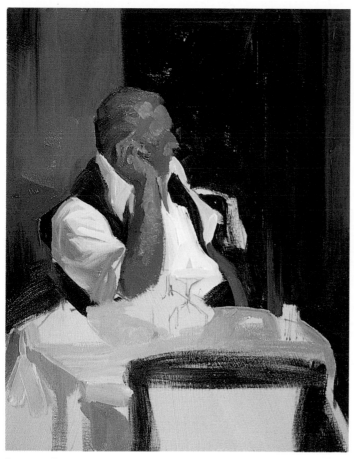

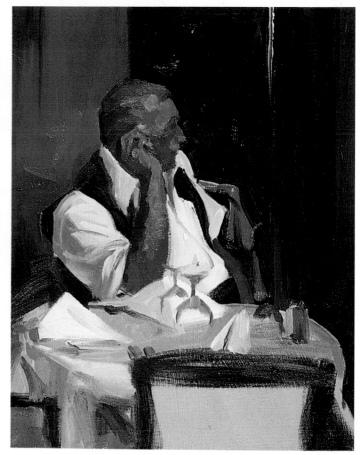

[**STEP 3**] The head and arm, the shirt and the tabletop are the next concern. Use the no. 8 bristle filbert, loaded with a warm white (Titanium White and a touch of Yellow Ochre), to freely lay in the light of the shirt. Reload the no. 8 bristle filbert with a slight gray-violet for the tabletop. Finally, add some lighter flesh planes to the head, arm and hand. Then add a bit of darker hair.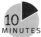

[**STEP 4**] Switching to a no. 6 bristle flat or filbert, begin to define some of the lighter elements on the table with a warm white and some gray-violet variations, defining some of the darker detail on the table. A bit more attention to the shirt is now necessary. Add a little more modeling in the fleshtones (both darks and lights) to help create a focal point.

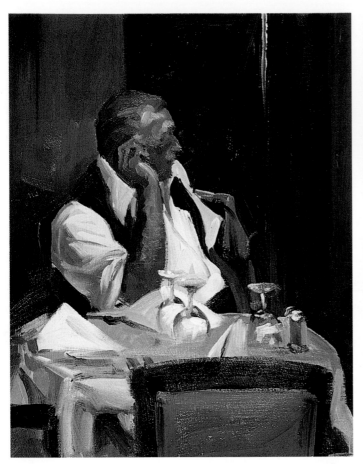

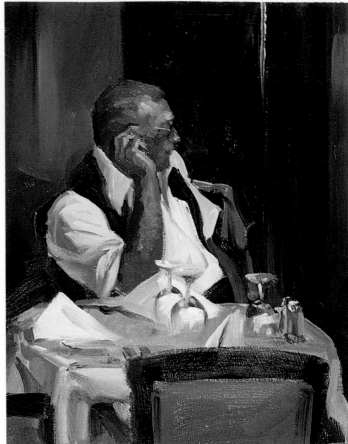

[STEP 5] A little more attention to the tablecloth should be next. Use a smaller, no. 4 bristle filbert to begin refining some of the tabletop elements. Again, further refine the shirt and face as they are more of a focal point. Now paint the bold back of the foreground chair.

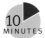

[STEP 6] After a quick evaluation, add a few glass highlights, further refine the head, hand and hair. These should all be sensitively painted with a no. 2 bristle filbert. Finally, add the eyeglasses on the face with a small round sable and Liquin, using only a couple of delicate strokes.

THE MANAGER'S TABLE • OIL • 60 MINUTES • 14" x 11" (36CM x 28CM)

Sunlight

Sunlight on a landscape will add drama to any subject. The striking, long cast shadows from a low angle of the sun, combined with the rich warm lights and cooler deep shadows, will emphasize the variety of forms in landscape and architecture. A painter must choose his vantage point with consideration of the sunlight direction and subject matter. The degree of contrast between light and shadow is based upon the sunlight's intensity and the value, hue and texture of the subjects affected. It is also important to note that sunlight is constantly changing, therefore rapid studies are ideal for capturing the fleeting light effect.

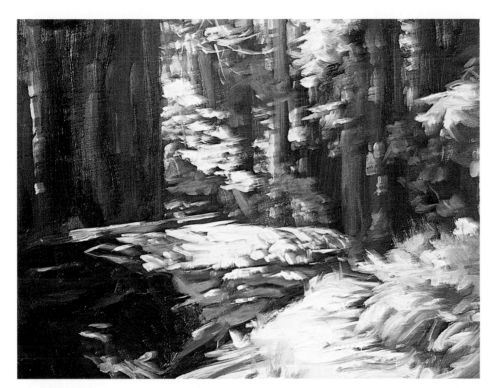

Dappled Light

Sunlight streaming through a dense grove of California redwoods gives a dramatic, dappled effect as the sunlight strikes trees, foliage, the log and the ground. The strength of the sunlight bounces up from the ground plane illuminating the lower planes of the fallen log in a warm golden glow. The filtering sunlight is so intense that it all but bleaches out detail in the ground, log and foliage into a warm white. It is the vertical dark warm shapes of the trees in shadow that offer the ultimate dark contrast.

BRIGHT LIGHTS • OIL • 50 MINUTES • 11" X 14" (28CM X 36CM)

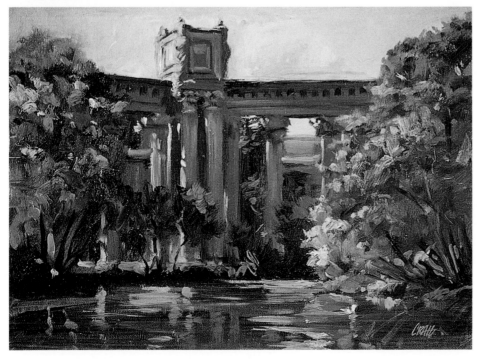

Glowing Light and Shadows

As the sunlight strikes the columns of the Palace of Fine Art, it is the cooler shadow side, affected by the blue sky, that gives solidity to the architectural forms. The contrast of the green foliage, and the glowing side lighting helps increase the intense dramatic effect of the sunlight. This is completed by the procedure of dealing with the larger shadow shapes, the smaller light shapes and finally the indication of shadow details.

SUNSHINE AT THE PALACE • OIL • 60 MINUTES • 12" x 16" (30CM x 41CM)

Interior Lighting

Lighting in an interior is generally very controllable. The amount of light, the number of light sources and the direction of light are all aspects of lighting, which may be completely controlled. An artist may choose to combine warm interior light with cool natural light from outside, or only use the artificial light source from inside. Usually artificial interior light sources are warm in relationship to the cool quality of natural outdoor light. Therefore, generally ambient interior lighting takes on a warm cast. However, it is possible to purchase a cool natural light in a photography shop, if a cooler light is desired.

Ambient Lighting
A figure seated in an interior is often how we see each other with an overall ambient light affecting the entire interior. Ceiling lights will often give this effect, bathing the interior in a warm light. The figure has been given further light definition to emphasize it as a focal point.

Comfy Chair • Oil • 40 minutes • 10" x 14" (25cm x 36cm)

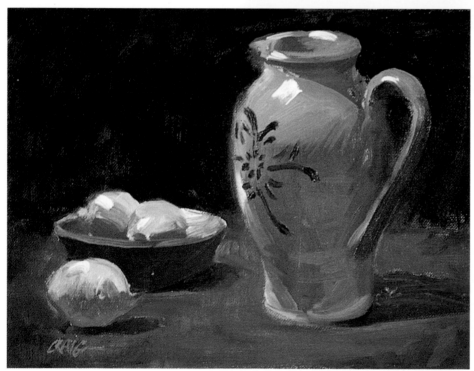

Strong Direct Lighting
The strong single light source that illuminates this simple still life utilizes the deep dark background to show off the intensity of the light. The warmth of the light source is complemented by the cool dark shadows (influenced by the dark and cool surroundings). It is the warm light that interrupts this cool dark environment, enhancing form and color.

Three Lemons • Oil • 25 minutes • 11" x 14" (28cm x 36cm)

Low-Angle Lighting

Lighting that breaks from the norm, and comes from an unexpected direction gives the viewer a unique perception of a subject. Artificial low-angle lighting may create a dramatic or eerie feeling as often seen in horror films. However, it may also enable a painter an opportunity to react and portray a subject in a provocative and uniquely beautiful image.

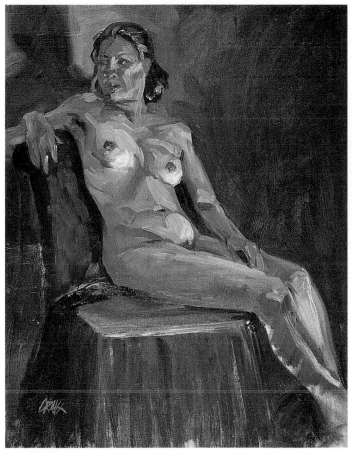

Lighting From Below
Light shining on the human form from below gives a painter an entirely new perspective on flesh tones as well as anatomy. Any light from above will tend to be subtler and cooler and often is a reflection of light from a light-colored ceiling. A cast shadow may often appear larger than the subject as it does here.

ON THE PLUM COLORED CHAIR • OIL • 40 MINUTES • 18" x 14" (46CM X 36CM)

Balance Warm Light With Cool Color
In order to not get too ghoulish when painting a figure lit from below, it is necessary to allow some ambient light to affect the top plane shadows. For this reason I often allow some cooler colors from above to help distinguish the difference from the warmer light from below.

THE WHITE CIRCLE • OIL • 40 MINUTES • 18" x 14" (46CM X 36CM)

Night Lighting

Night lighting often shows the actual light sources. The stages of night, from early evening to late night, offer many variations in the overall nighttime color quality. Shadows will generally be very dark and often disappear into the night. The drama of night lighting is always evident in mood and the severe value contrast.

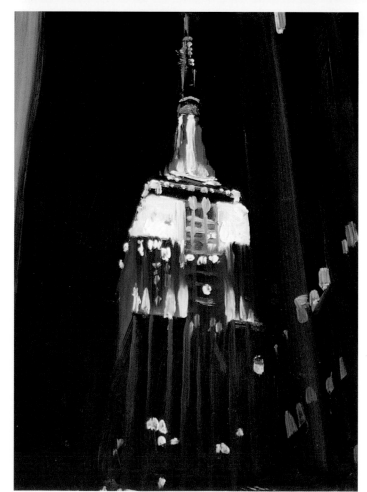

Composing With Light
The strong light pattern created by shop lights creates a dynamic diagonal composition, breaking into the dark of night. Some of the light effect spills over, defining a bit of the architecture, the automobiles and the street.

SUTTER STREET • OIL • 50 MINUTES • 11" x 14" (28CM x 36CM)

Light as the Focal Point
The black of night is pierced by the lights on the Empire State Building. As always, when dealing with architecture, perspective is a major concern; it's even more so when looking up at a dramatic angle.

NEW YORK NOBILITY • OIL • 40 MINUTES • 14" x 11" (36CM x 28CM)

Atmosphere in Lighting

As light affects atmospheric conditions, it creates a distinct quality of distance. The atmosphere itself may create the illusion of distance in a scene. The artist may use this to give their painting more mood or the illu-sion of great depth. Atmospheric conditions were the motivation for painters such as Claude Monet, J. M. W. Turner, and plein air painters Sam Hyde Harris and John Henry Twatchman.

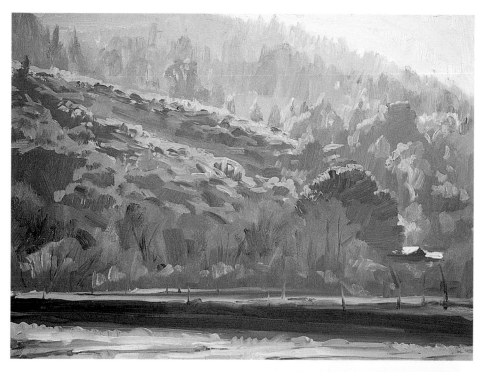

Mid-Day Haze
Peering through an atmosphere of haze in the midday sun softens and unifies the varied colors of the landscape. It is the density of the atmos-phere that gives a high-key quality to this and other paintings like it.

PINK AND GREEN HARMONY • OIL • 50 MINUTES • 12" X 16" (30CM X 41CM)

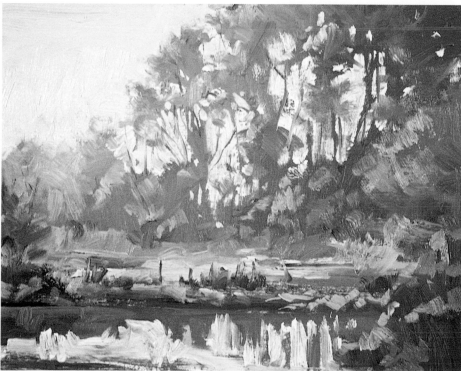

Light Through Mist
This high-key painting relies on a very close range of colors and a value range where nothing is darker than about a 50 percent gray. As the trees recede in the distance, they become closer to the sky tone as the mist almost engulfs them.

COASTAL MIST • OIL • 25 MINUTES • 8" X 10" (20CM X 25CM)

Sunlight Streaming Through Atmosphere

Sunlight streaming through a slight atmospheric condition is a theme that Turner explored, at times almost losing the subject matter. The sunlight not only illuminates the subject but the atmosphere itself, especially in the late afternoon sun.

Materials List

Paints

Alizarin Crimson · Burnt Umber · Cadmium Red Light · Cadmium Yellow Light · Cerulean Blue · Sap Green (Hooker's Green for acrylics) · Terra Rosa (Red Oxide for acrylics) · Titanium White (a soft formula for oils, Gesso for acrylics) · Ultramarine Blue · Viridian · Yellow Ochre

Brushes

Nos. 1, 2, 4, 6, 8, 10 and 12 hog bristle filberts · Nos. 4, 6, 8, 10 and 12 hog bristle flats · Large sable flat for oils · Large 2- to 3-inch (51mm–76mm) flat for acrylics

Mediums

Liquin for oils · Water for acrylics

Other

12" x 16" (30cm x 41cm) Masonite or canvas · Container—a plastic bucket for acrylics or a silicon jar for oils · Palette · Palette knife · Timer

[**STEP 1**] On a light neutral toned piece of Masonite, paint a quick light sketch of the basic shapes to give a compositional theme. Apply a pale group of tones in the background using very close values with a no. 10 bristle flat or filbert.

10 MINUTES

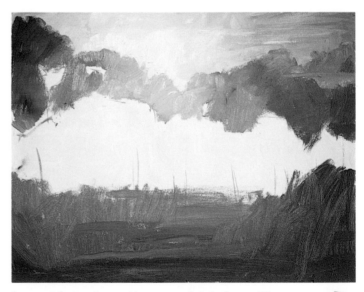

[**STEP 2**] Continue with a no. 10 bristle flat or filbert and establish most of the close value middle darks, looking for some color variation. Concentrate on the atmospheric warm color quality. Avoid going too dark but keep in mind where the intensity of the sun is (top center).

10 MINUTES

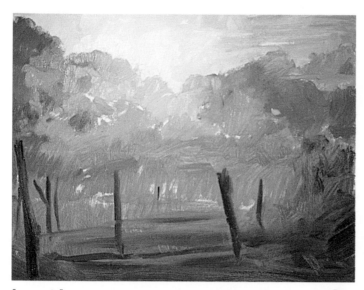

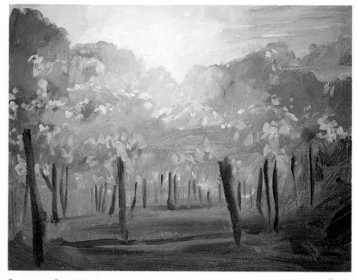

[**STEP 3**] Again with your no. 10 bristle flat or filbert, block in the golden atmospheric effect on the main subject of the vineyard foliage. Add a couple of the stronger vines with a no. 8 bristle filbert. The total atmospheric look should basically be there by now.

[**STEP 4**] With the no. 8 bristle filbert, slow down a bit and concentrate on the distant vines and stakes. Slowly begin to develop the warm yellow light on the vineyard foliage, keeping the values close. Use a well-loaded brush and smaller strokes to depict leaves.

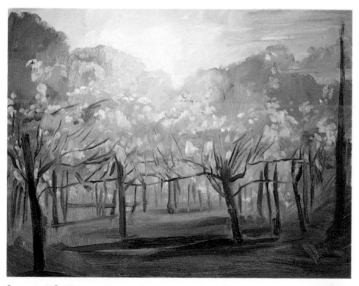

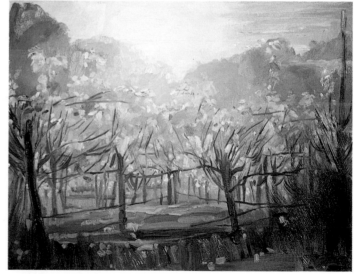

[**STEP 5**] The progress always appears slower as the painting nears completion. This is because the big effects are usually done by now, and more subtle detail and slower fine-tuning are the concerns. With the no. 8 bristle filbert, continue developing the lush qualities of the foliage. Loosely add in some more branches as you begin to focus more on linear detail.

[**STEP 6**] Finally, using a no. 4 bristle filbert and a light delicate touch, focus on the smaller details such as smaller branches, more foliage variation, ground textures and color variations. Emphasize darks (only a little). A few color variations in the foreground will indicate some flower and weed shapes. A possible adjustment here and there in the sky helps the atmospheric glow effect.

VINEYARD GLOW • OIL • 60 MINUTES • 12" X 16" (30CM X 41CM)

Mood From Lighting

Mood created through lighting may be caused by deep dramatic shadows, contrasting backlighting or an interesting direction of a light source. Moody lighting often deals with a dull or unified color scheme, but a moody piece may be colorful and be created by a unique angle of light. Although the mood of a painting may be created by the light, it is the concept of mood that a painter must concentrate on while working. This may include elimination of detail, losing edges into shadow, or purely a unified color effect.

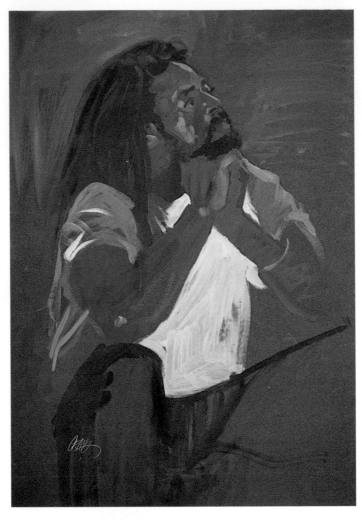

A Dark-Toned Background Sets the Mood
The mood here is set by working on a relatively dark-toned surface and using a warm and a cool light source. Allowing the majority of the shadows to relate to the darker background helps set up for the brighter, more colorful light from below. Finally, cooler secondary backlight from above is added as an accent.

THINGS ARE LOOKING UP • OIL • 40 MINUTES • 28" x 18" (71CM x 46CM)

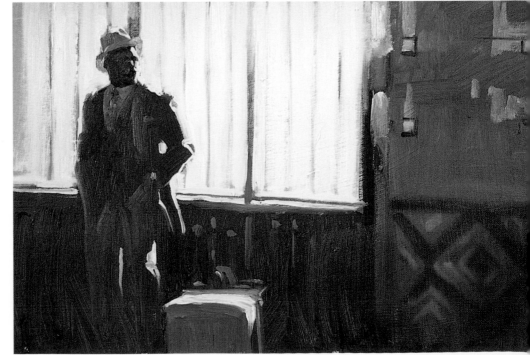

Use Backlighting to Set Mood
The light streaming in from outside creates a strong contrast to the relatively dark warm interior. The striking light-and-dark pattern creates a powerful composition with the breakup of space. The backlighting from the window gives a hint of detail, but the mood comes from what we do not see, the elimination of detail.

INSIDE THE STATION • OIL • 45 MINUTES • 12" x 18" (30CM x 46CM)

Time of Day

Lighting can often convey the approximate time of day. The angle of the sun is the main indication of time of day. Morning light will tend to be cooler since the ground and atmosphere are not yet warmed up. Late afternoon light is warmer as it leads to sunset, which is often very warm and sometimes fiery in its color. Shadow length is another telltale feature dictated by the sun. Most plein air landscape painters prefer early morning or later afternoon for a more dramatic light effect.

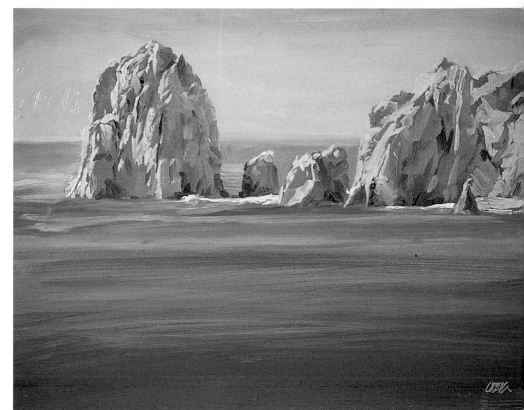

Morning Light
Morning light is cooler than evening light. The atmosphere is still cool and, although the light will be bright, it will not be as warm as light later in the day.

CABO MORNING • OIL • 45 MINUTES • 12" x 16" (30CM X 41CM)

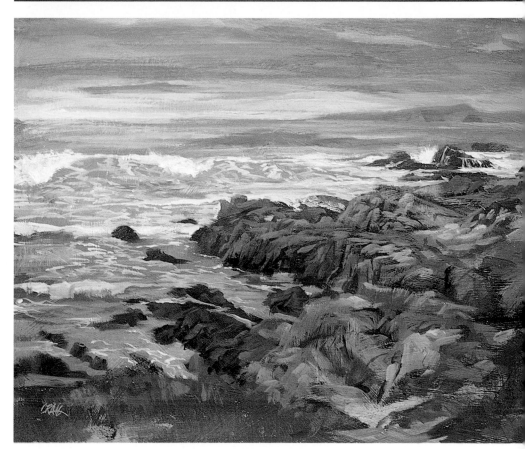

Afternoon Light
Pacific Grove Surf was painted in late afternoon looking west, on what was a gray day. Toward the horizon, a clear sky shows a yellow quality from the lowering sun. The rest of the subject is receiving an overall cool gray light. Light and shadow contrasted in rock forms are minimized. When painting surf, it is advantageous to watch the character of the breaking waves and their rhythm before indicating them as simply as possible. The light, colorful sky accent is added and accentuated at the very end.

PACIFIC GROVE SURF • OIL • 60 MINUTES • 16" x 20" (41CM X 51CM)

Low-Angle Afternoon Light

Looking down a mission corridor, the attraction of the low-angle afternoon light and cast shadows is inspirational.

Materials List

Paints

Alizarin Crimson • Burnt Umber • Cadmium Red Light • Cadmium Yellow Light • Cerulean Blue • Sap Green (Hooker's Green for acrylics) • Terra Rosa (Red Oxide for acrylics) • Titanium White (a soft formula for oils, Gesso for acrylics) • Ultramarine Blue • Viridian • Yellow Ochre

Brushes

Nos. 1, 2, 4, 6, 8, 10 and 12 hog bristle filberts • Nos. 4, 6, 8, 10 and 12 hog bristle flats • Large sable flat for oils • Large 2- to 3-inch (51mm–76mm) flat for acrylics

Mediums

Liquin for oils • Water for acrylics

Other

12" × 16" (30cm x 41cm) Masonite or canvas • Container—a plastic bucket for acrylics or a silicon jar for oils • Palette • Palette knife • Timer

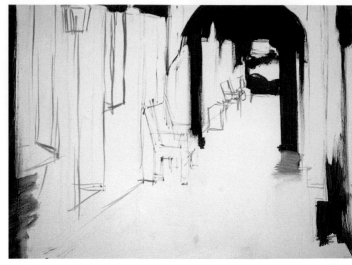

[**STEP 1**] The importance of perspective requires a more accurate sketch. Lay in this sketch on a light neutral warm toned piece of Masonite, 12" x 16" (30cm x 41cm), with a no. 2 bristle filbert. The darkest tones should then be established with a mixture of Burnt Umber and Ultramarine Blue (leaning a little warmer) with a no. 10 bristle flat.

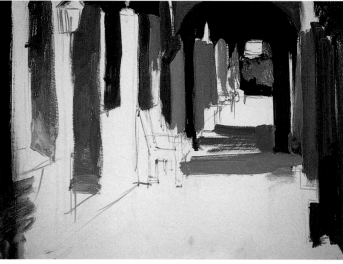

[**STEP 2**] Begin at the distant wall and move up to the foreground, working on the shadow tones and paying special attention to the variations of warms and cools.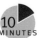
Vary these from gray-violets and rust tones to warm ochres as the subject dictates (observe carefully). These color nuances are local color variations and the effect of reflected light off of walls and ceilings. A no. 8 bristle flat or filbert or a no. 10 bristle flat or filbert will work best.

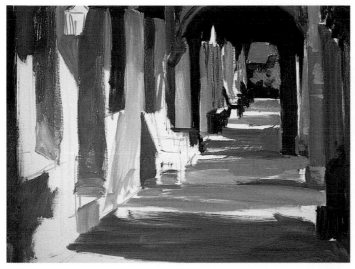

[STEP 3] Continue to concentrate on the shadow patterns, the subtle color changes and value variations using a no. 8 bristle flat or filbert. The tone of the board is acting as a light at this point. By now the total basic effect of the painting should be established and evaluated before continuing to the next step.

10 MINUTES

[STEP 4] It is important to make sure all of the elements are in place. Indicate any additional subjects, such as the foreground bench and lamp. Subtle color changes and gradations in the shadows need to be manipulated (both darker and lighter) with the no. 8 flat. Now paint the warm light striking the ground and walls with a fully loaded no. 8 flat. Pay special attention in refining shadow shapes by using the light to carve in and further define.

15 MINUTES

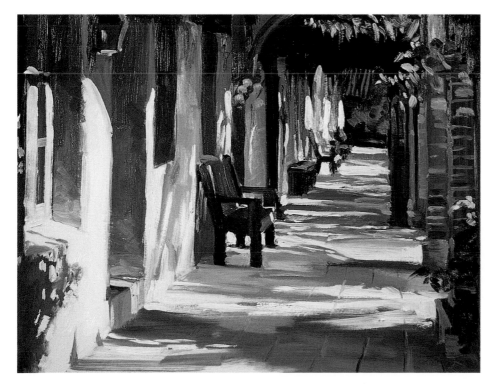

[STEP 5] Continue to refine the shadows; pay attention to shadow detail and refinement. These need to be addressed sensitively with nos. 2 and 4 bristle filberts. Indicate the brick forms on the columns, the tiles on the corridor and some foliage creeping in. Paint a bit of warm light striking some of the leaves to complete the afternoon light effect.

15 MINUTES

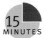

LATE AFTERNOON AT THE MISSION • OIL • 60 MINUTES • 12" x 16" (30CM x 41CM)

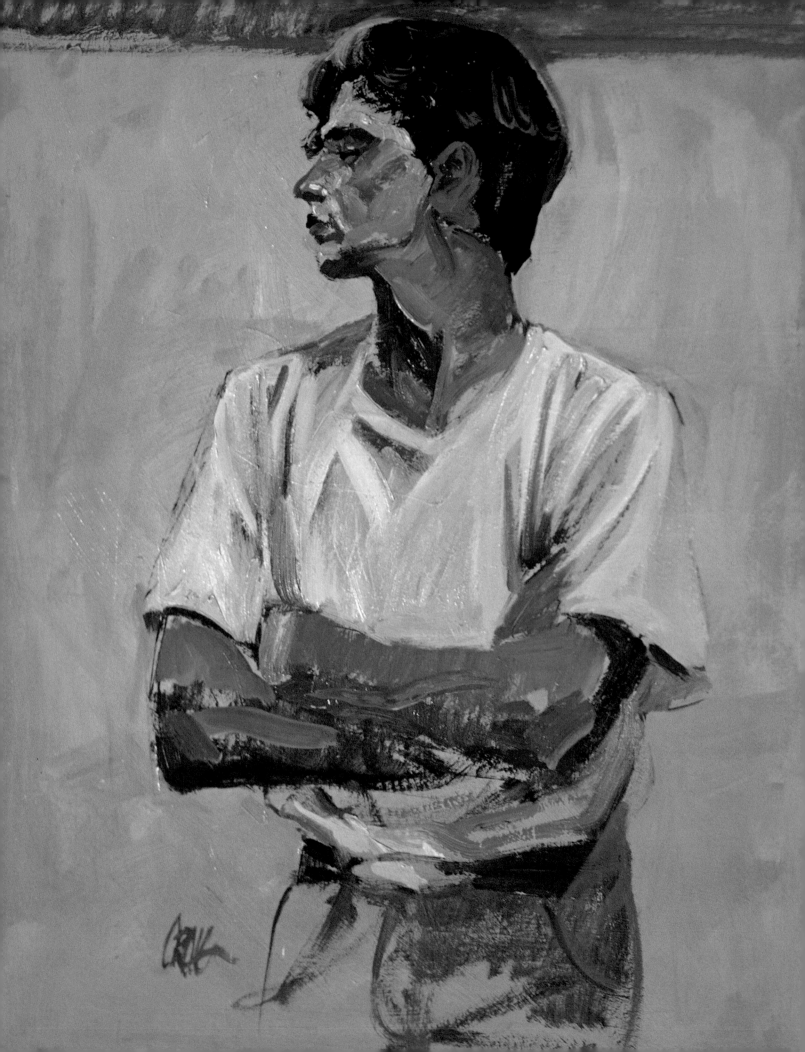

Finishing a Painting

After producing a series of studies, you may decide the subject is an appropriate item for a finished painting. A particular study may serve as inspiration for a larger, more refined piece. Each artist must determine why they wish to do a finished piece based on that particular study. What grabbed their interest? Design? Composition? Color? Subject matter? Mood? Lighting? Or something else? Whatever the reason or reasons, that factor must remain a primary concern of the final piece.

The approach of this finished painting is much the same as the quick study, with the obvious difference in the time frame for each stage. As in the study, the composition—placement of elements—begins the piece in sketch form. From here you must go through the lay-in stage, developing form and slowly refining and defining areas as you deem necessary. During the development of the painting, brushstrokes, edges, color nuances and the degree of finish are all concerns. This is a luxury not afforded in the study.

Exaggerate Color Temperatures
I concentrate on the intensity of the color in the fleshtones, purposely overexaggerating the various temperature changes within the fleshtones based on structure. I wanted to see how far I could push color without losing a feeling of reality. I, therefore, could not make the T-shirt white. To make it feel whitish, I used a slightly warmer muted yellow.

T-Shirt • Oil • 40 minutes • 20" x 16" (51cm x 41cm)

Study For Finished Painting

If studies are truly intended for the purpose of examining possibilities, whatever they might be, then it stands to reason that they may inspire a larger, more developed painting. It could be the design that is the motivation, the lighting, the subject or something else. A study, in this case, becomes more or less an abbreviated trial run.

The larger, finished version from the study is usually more thought out and more carefully refined. Each painter must decide what aspects of the study should remain as originally stated, and what needs improvement or refinement. This requires an objective evaluation, which is generally not made immediately, but after some time has passed. A vision is necessary to move beyond the study. Many artists are either too easily satisfied, or so overly self-critical that they don't attempt a more finished version. Don't fall into this trap.

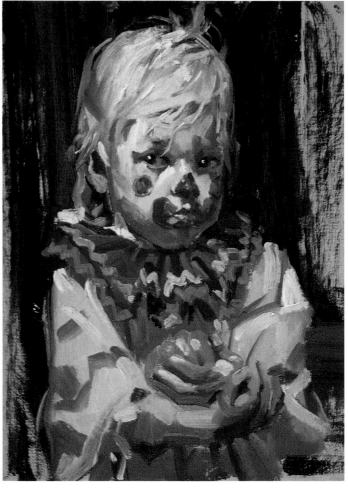

Study
The attitude of the figure combined with the facial expression inspired me to further develop this subject (not to mention it is of my daughter).

LITTLE CLOWN STUDY • OIL • 30 MINUTES • 7" x 5" (18CM x 13CM)

Final
The body language, expression, and care in painting have been refined with regard to the drawing and sensitivity of the painting. In a more intimate portrait such as this, the focus is primarily on the face, with the body and hands more supportive. In terms of vision, it was to keep the exterior edges softer, and less brittle, while using sensitive darks and more defined accents in the facial expression.

The size of this finished painting was determined by the intimacy of the portrait. A painting done too large would make the child's head larger than actual size, which is undesirable.

THE PUMPKIN PROTECTOR • OIL • 24" x 18" (61CM x 46CM)

Evaluating Possibilities

In landscape painting the possibilities are endless. Lighting, subject matter and composition are the ingredients that each painter must evaluate and respond to. The following three locations are within a few miles of each other, and were all possible studies for finished paintings.

First Study

Dramatic afternoon light and shadow, and a rustic man-made bridge were inspirational for choosing this subject. A quick bold study captured the feeling.

BRIDGE ACROSS THE SNAKE • OIL • 40 MINUTES 7" x 11" (18CM x 28CM)

Second Study

Reflections, foreground shadow color, and atmospheric detail in the midground and background were the motivation for this study. The small size allowed for this to be completed quickly with nos. 2, 6 and 8 bristle brushes.

NEAR OXBOW BEND • OIL • 25 MINUTES • 5" X 8" (13CM x 20CM)

Third Study

Mood and composition were the primary factors in this study. The early, even glow from the sun accented the simplicity of the mountains, while the shadowy foreground demands more detail.

EVENING AT GRAND TETON • OIL • 40 MINUTES • 7" x 11" (18CM x 28CM)

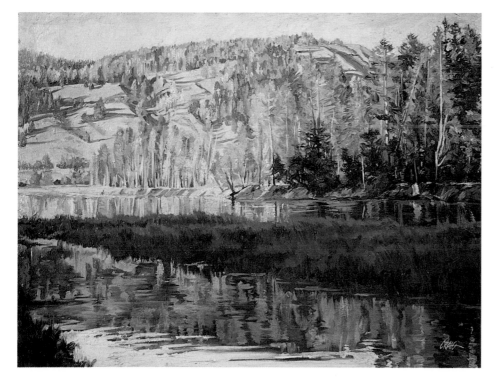

Final

Any one of the previous studies would most likely make an interesting finished painting. The choice here was made based on a new challenge. The close value of the background trees and shadows, and the rich cool greens in the foreground foliage combines with the near abstract reflections to create a provocative harmony in the painting.

At some point, it is possible that the other two studies may be developed into larger finished works. This is one advantage of having several studies to choose from and continually evaluate.

SHADOWS AND REFLECTIONS • OIL • 18" x 24" (46CM x 61CM)

Developing Details

The evaluation process here has to do with selection of refinements and development of details as this study moves to a finished painting.

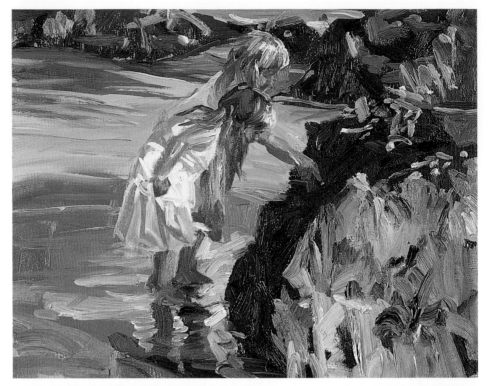

Study

This study is an observation of varied subject matter, gesture, lighting and composition. It was done with large bold strokes, working out only value patterns and color variations.

DISCOVERY • OIL • 50 MINUTES • 11" X 14" (28CM X 36CM)

Final

Three thoughts come to mind when approaching this finished painting based on the study. First, create a foreground and background effect. Second, make the figures a more refined focal point. Third, consider a painterly, but detailed, feeling to the foreground rock forms.

The first two considerations are easier to deal with. Lightening the background value keeps it from competing with the foreground. The focal point of the figures is a matter of slowing down, developing them through more refined stages and adding some pattern to the pink dress. The foreground rocks are achieved by utilizing a large no. 12 brush loaded with paint and boldly painting various colorations wet-into-wet. The feeling of the mussels is added at the end.

DISCOVERY AMONG THE ROCKS • OIL • 24" X 30" (61CM X 76CM) • PRIVATE COLLECTION

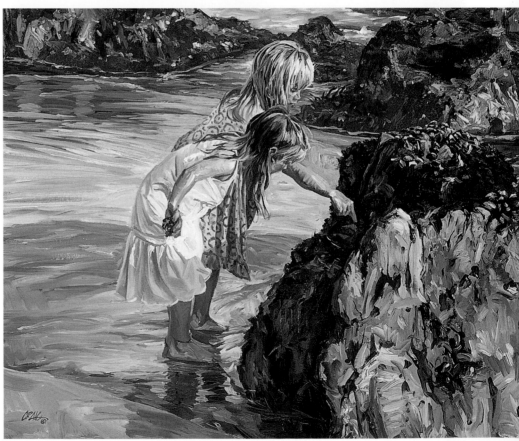

Changes in Content

The whole process of attempting a finished painting based on a study requires the concept of changes, as well as refinements. Here the major change has to do with content.

Study

Value pattern and composition were the considerations in approaching this study. Paint was boldly and thickly applied to create the activity and indication of the detail.

MORNING ORDER • OIL • 60 MINUTES • 11" X 14" (28CM X 36CM)

Final

Evaluation led to the decision that a second figure would help the overpowering pattern of the bottles on the shelves. A simple bold pattern on a dark dress was chosen. A white skirt was used in place of slacks for the other figure.

The complex drawing in the final painting was developed more slowly and accurately before beginning the painting process. A complex finished painting such as this is accomplished best over several sittings and by not trying to finish it too quickly.

TWO LATTES TO GO • OIL • 24" X 36" (61CM X 91CM)

Studies From Photographs

Studies of animals may be done quickly on location, but usually a photograph is necessary to authenticate detail and anatomical accuracy. In this case the study was based on a photograph I shot while sketching.

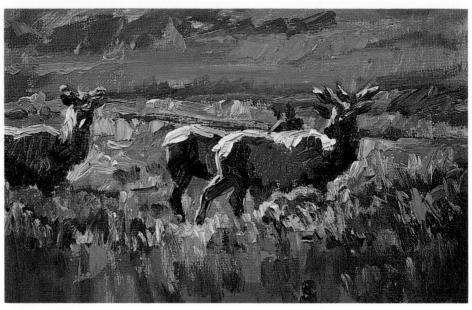

Reference Photo

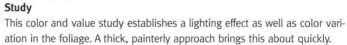

Study
This color and value study establishes a lighting effect as well as color variation in the foliage. A thick, painterly approach brings this about quickly.

POINT REYES TULE ELK • OIL • 40 MINUTES • 7" x 11" (18CM x 28CM)

Final
Although the study acted as inspiration, a more dramatic background seemed appropriate. I have sketched and painted in the Point Reyes area many times and knew the drama of the distant Pacific Ocean below would be inspirational and appropriate. Since the elk were not in this exact location, combining them with the new background required sensitivity to consistency in lighting, perspective and atmosphere. It was important to develop the distant atmospheric quality before refining the subtlety of the elks' coloration, and refinement of the foreground.

GUARDIANS OF THE POINT • OIL • 15" x 30" (38CM x 76CM)

Changes in Proportion

It is not unusual, in the evaluation of a study, to realize that a particular piece might work better in a different proportional format. Sometimes it is just a matter of recropping, while other times additional subject matter is required.

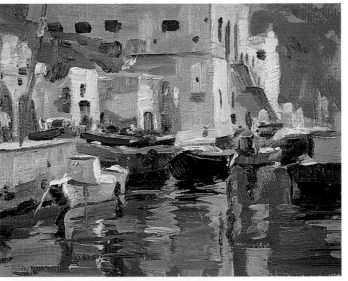

Study

A lot of activity and perspective was the driving motivation in this study. The lack of any intense color and the subtle off-white variations also presented a challenge.

AEGEAN BOATS • OIL • 55 MINUTES • 8" X 10" (20CM X 25CM)

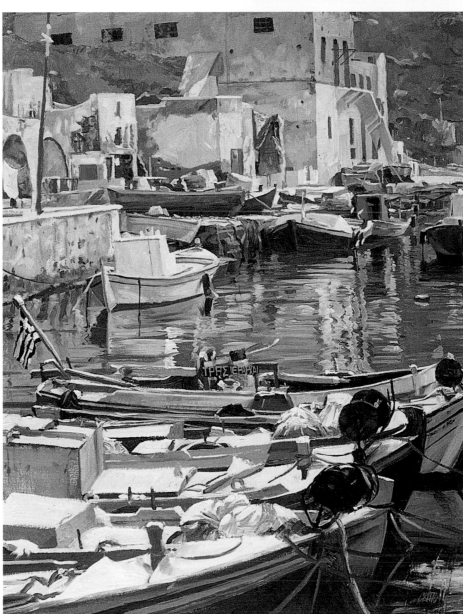

Final

Although the study basically accomplished the desired results, it feels a bit too much on one plane. Changing the composition to a more vertical format, and adding a foreground group of boats to look past, gives the overall piece a more desirable effect. In order to bring the foreground group of boats closer, stronger value contrast and a bit more color intensity assists in the endeavor.

AEGEAN HARBOR • OIL • 30" X 24" (76CM X 61CM)

Changes in Scale

The choice of scale or size of a finished painting may be determined by several factors. Subject matter, composition and personal vision are all considerations when deciding on a size and change of scale.

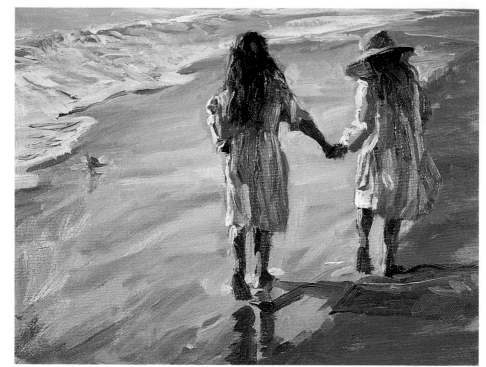

Study

Establishing readability through value relationships and color variation in shadow detail were the primary concerns of this study.

WALKING MALIBU • OIL • 45 MINUTES • 11" x 14" (28CM x 36CM)

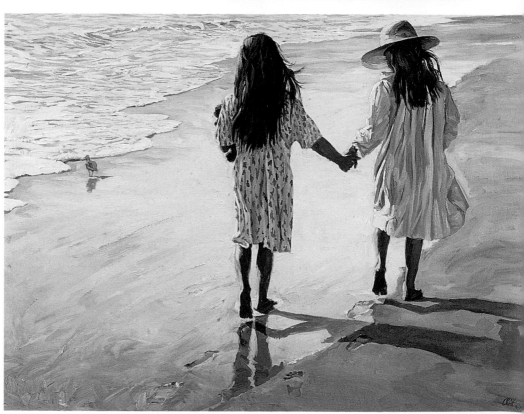

Final

The scale change here had to do primarily with the size of the two girls. They needed to be large enough to fully develop the subtle character of the white dresses. Areas such as footprints and reflections were also more refined as a result of the larger size. A higher-key palette enhanced the beach lighting. Many times a painter may choose a larger format because it feels right to do so. The more you paint, the more you get a feel for the scale in which you wish to work.

SUMMER FRIENDS • OIL • 30" x 40" (76CM x 102CM) • PRIVATE COLLECTION

Study

The movement and activity of this vineyard worker was the attraction for this study. However, it felt too quiet for the overall vineyard activity. When painting figures in action, a photograph is best for accuracy. When going out on a harvest such as this, I arm myself with a Pochade box for vineyard sketches and a camera for the quick moving-figure activity.

CARRY THAT LOAD • OIL • 50 MINUTES • 10" X 8" (25CM X 20CM)

Final

The solitude of the singular figure in the study needed more. The gesture was a dynamic central pose to build more activity around. Changing scale to a larger format allowed for more of the additional activity to come into play. The main focal point was the figure from the study. My only regret was that I had not painted this larger. A 36" x 48" (91cm x 122cm) canvas would have been more appropriate.

CHARDONNAY JOURNEY • OIL • 24" x 30" (61CM x 76CM)

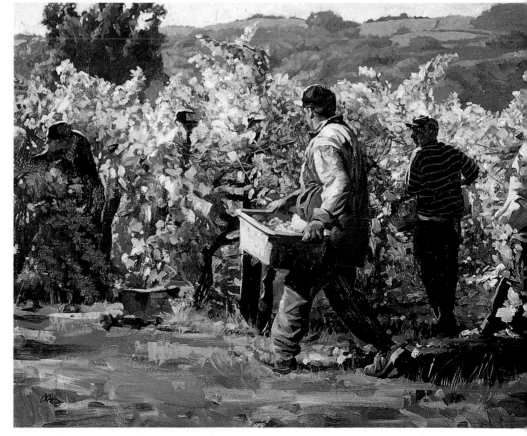

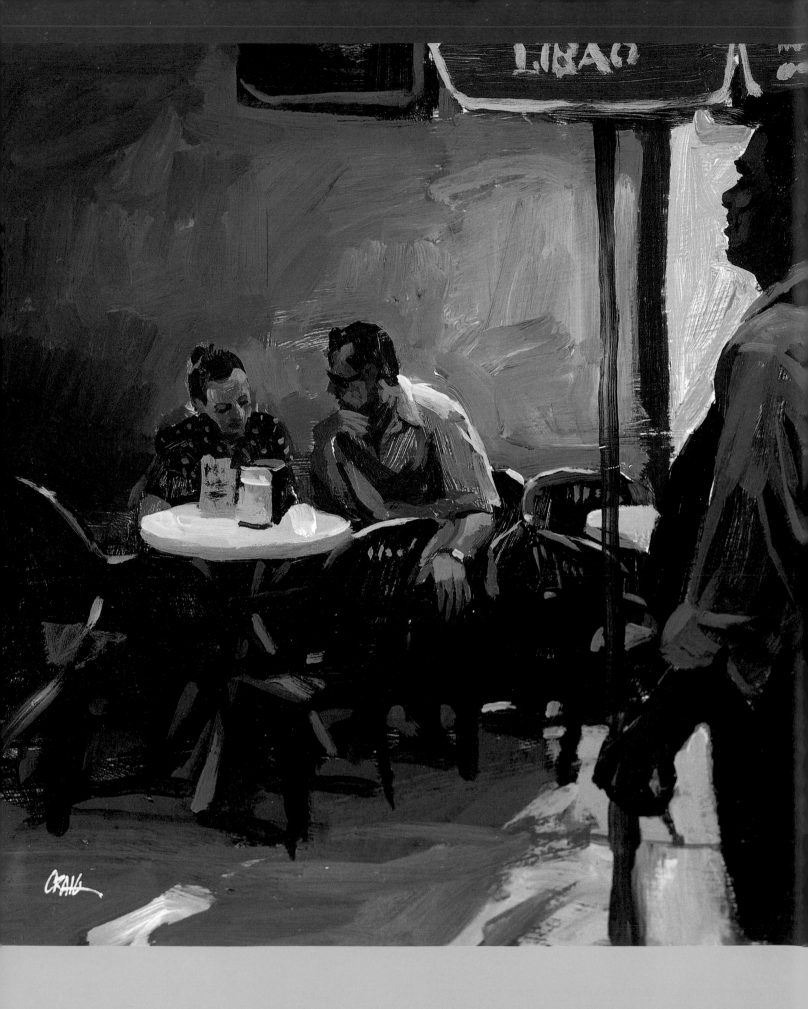

Recreation and Practice

Studies can be a great form of recreation. Pack a thermos of coffee, a small ice chest, a lunch, a Pochade box or French easel and strike out from your home until something inspires you. With a few small panels or canvases, it is possible to take off for a few hours and do three or four quick studies just for the joy of it.

Each study is a form of practice. The sense of eye-hand coordination and the repetitive observation is necessary in each one. A quick study further develops a painter's skills. Therefore, even if the intent is recreation, one cannot help but to improve.

What's Important?

My prime concern in this piece was design. This is evident through the strong light and dark break up of graphic space. This is composed from two photographs that I shot in New York's Little Italy. The two seated figures silhouette nicely against the lighter-colored red wall. Another consideration, which contributes to the design, is the dramatic light and shadow. Thus, light source and ambient shadow light also are a concern. The foreground figure is completely in shadow.

This acrylic painting used large bristle brushes to do most of the work. Smaller nos. 4 and 6 brushes were used toward the finish. Finally, a no. 4 synthetic sable round was used for the final 5 minutes to refine the detail.

DECIDING ON LUNCH • ACRYLIC • 60 MINUTES • 20" x 15" (51CM x 38CM)

In the Studio: Figure or Still Life?

It is not necessary to leave the studio for recreation. You may set up a still life or get a friend or relative to sit for a quick study. It is often enjoyable to have someone you know sit for two or three 20-minute sessions. The familiarity may make it easier and the fact that it is a study and not a finished painting allows for great practice.

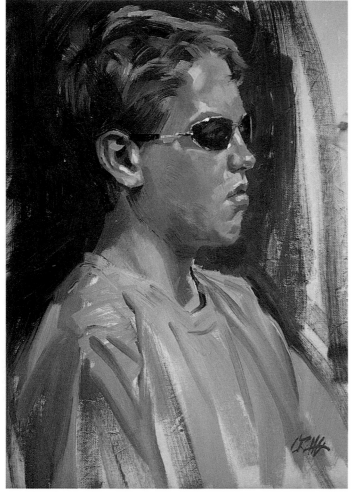

Figure Studies
My son posed for three 20-minute sessions. The first twenty minutes were spent on a semiaccurate proportional sketch on a light gray canvas. I determined the basic light and shadow fleshtones as well as the basic darker hair shape. Stages two and three consisted of developing subtle color and value variations based on structure. I was able to carry this to a more finished state because this is a profile and the sunglasses eliminate eye structure.

IAN • OIL • 60 MINUTES • 16" X 12" (41CM X 30CM)

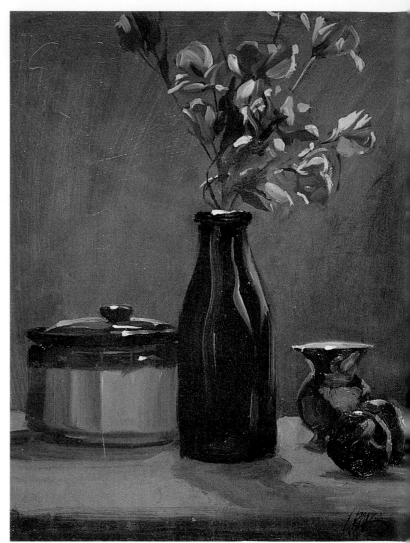

Still Life Studies
The backlit still life allowed for the practice of painting shadow detail. Most of my time was spent developing the subtle tonal variations facing me. The bright light accents were added during the final 8 to 10 minutes.

THE BACKLIT SET UP • OIL • 45 MINUTES • 14" X 11" (36CM X 28CM)

Gathering Information

An artist who wishes to do a series of paintings or a large major work on a given subject needs to research the topic. There are three basic forms of visual research to gain familiarity with a subject. Photographs are a great documentary source capturing moments, actions and details. Sketching in pen or graphite requires observation and gives the artist an opportunity to study the particulars of a subject. The quick study forces the painter to focus on the color notes, value and edge qualities of the subject. Combining these gives a wonderful source of information and study to build upon.

Sketches of Grape Harvest

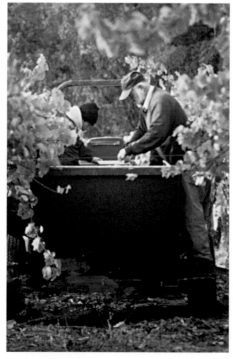

Photo Reference

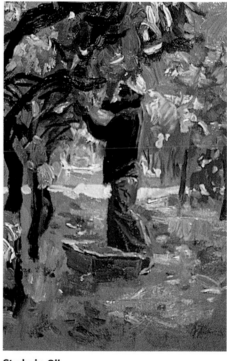

Study in Oil

QUICK PICK • OIL • 25 MINUTES • 9" x 6" (23CM x 15CM)

Painting on Vacation

Many artists plan a painting holiday. Often this is a great inspirational getaway. Finding new and exciting subjects, or just changing one's painting venue, may be a great stimulation for a variety of field studies. It's also possible that your vacation may not be a painting holiday, but a family vacation. In this case, you may wish to take along supplies to do a study or two during your trip.

When planning a painting holiday, or a holiday in which you may paint, supplies must be planned. It is probably best to assume that you will not find the supplies you need at the destination. Therefore, it is crucial for you to plan for, and organize, the supplies you will need.

Acrylics are easier to take than oils since turpentine is not needed and storing wet paintings is not an issue. If travelling by airplane or to another country make sure the supplies you take are not hazardous or illegal.

French Easel
The half French easel is accompanied by a turpentine can and two prepared panels.

Case for Wet Canvases
This carrying box was constructed to carry wet 11"x 14" (28cm x 36cm) panels and one wet canvas.

Supplies

Paints—a variety of colors from your palette

Brushes—a variety of sizes

Half French easel or a Pochade box

Palette (usually carried in the French easel or Pochade box)

Solvents and mediums—turpentine container with lid for oils or water for acrylics

Turpenoid Natural (noncombustible)—Do not take any form of combustible turpentine if you are flying.

Paint rags

Painting surfaces—gessoed Masonite panels or canvas mounted on panels is better than stretched canvas to conserve space. Keep the panels the same size such as 11" x 14" (28cm x 36cm) or 9" x 12" (23cm x 30cm).

Container to carry wet paintings—I have seen a huge variety of solutions for this. I use a box with appropriately sized slots that I had constructed.

Painting hat to shield the sun

Sunblock

Timer or wristwatch

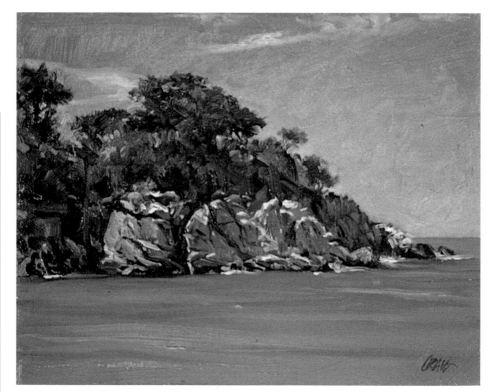

Painting on Vacation
I recall sitting on the beach while painting this. It helps to paint this in the following order: water, sky, foliage and rocks. The procedure of painting from background to foreground should be followed with simple large shapes. The detailed attention of the foliage and rock forms are refined more slowly in the final 30 minutes. Careful focused observation is necessary for this final stage.

MISMALOYA • OIL • 60 MINUTES • 8" x 10" (20CM x 25CM)

Sharpen Your Skills

Quick studies can greatly sharpen your skills. This is especially so when you attempt something that doesn't come easy to you. Practicing what you don't usually paint will force you to observe and understand more, instead of falling into a comfort mode of familiar colors, shapes and strokes.

Painting anything is better that not painting at all. A rapidly produced study is less intimidating than a painting that will produce a finished or refined result. It will allow for more risk taking and will enhance your skills.

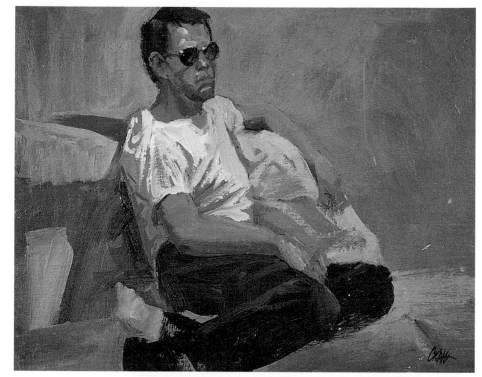

Simplify Your Paintings
Simplification is tremendously important in this painting. The painting basically breaks down into the background, pants, shirt and fleshtones. Elements such as the pants and hair rely on shape, while the face and T-shirt show more detail in form and modeling.

SUNGLASSES • OIL • 40 MINUTES • 11" X 14" (28CM X 36CM)

Hone Your Observation Skills
A larger quick study of a nude with a striking gesture is a formidable challenge. The light source is placed low for a more dramatic effect. Figure painting always requires more attention to proportion and gesture. The lack of large clothing shapes makes anatomy even more important. The goal was to create accuracy in form, color and drawing in two 20-minute sittings. Observation skills need to be acute for this particular exercise.

SEATED GESTURE • OIL • 40 MINUTES • 20" X 16" (51CM X 41CM)

Brush Mileage

The term *brush mileage* refers to painting experience. There is an intuitive aspect to successful painting much the same as a good tennis player, basketball player or skier develops an intuitive aspect to their skills. Many artists wish to be good immediately, which is impossible. The way one becomes skilled at anything is through constant repetition. The study is a tremendous source of brush mileage, and has been so for centuries.

The pure joy of painting, the feeling of applying paint, and the excitement of the creative process are integral in gaining brush mileage. A variety of subjects will add a variety of skills to any painter's repertoire of brushstrokes.

Practice on a Still Life
Pulling out pots and pans and setting up a still life will require a creative brush to give a metallic look. Color also is a concern here. You must observe and study the various warm and cool grays.

Pots and Pans • Oil • 40 minutes • 9" x 12" (23cm x 30cm)

Practice on a Landscape
A plein air landscape with tree forms and water offers a different set of challenges. Edge control plays a prominent role to convey the softer leafy quality of the tree shapes. A strong top-sunlight effect is constant throughout.

The Stone Bridge • Oil • 45 minutes • 11" x 14" (28cm x 36cm)

Painting With Time Limitations

One of the greatest aspects of quick studies is the brief amount of time it takes to complete one. Because of this short time frame, it is possible to take some time during a day and set up to do a brief study of almost anything. A backyard or corner of the studio can serve as inspiration. The important thing to keep in mind is to keep the study mentality. It is like sitting down at a piano, picking up a guitar, or swinging a golf club in the backyard. In order to improve, practice and repetition are required. Take a break, take some time, practice and enjoy!

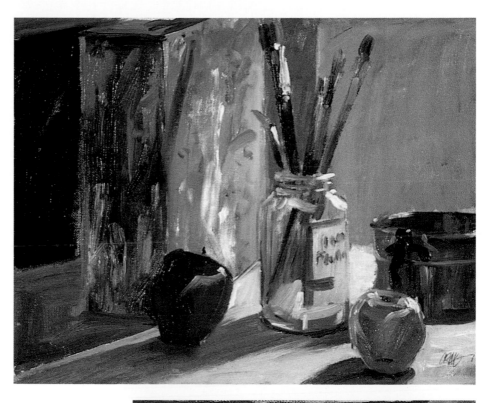

Paint in the Studio
When unsure of what to do, look around the studio. Supplies make for great subjects. They need only a light source and presto, they become a still life. Apples may be added for a bit of color. The variety of shapes and textures is the primary consideration here.

STUDIO GOODIES • OIL • 40 MINUTES • 11" x 14" (28CM x 36CM)

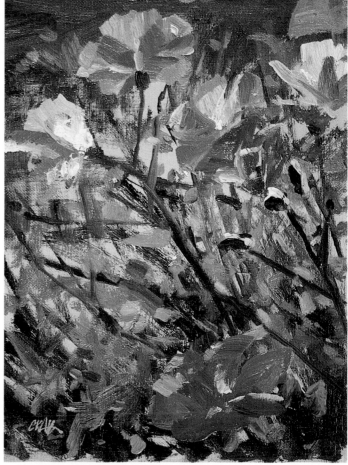

Paint in Your Yard
A corner of a backyard garden may offer a new and challenging subject. The organic chaos of the abstracted varied greens must be built up as a background before concentrating on the focal point of the flowers and stems. It is important to stay with a larger brush, nos. 8 or 10 bristle flat, so that the background foliage stays undefined.

INTIMATE GARDEN • OIL • 40 MINUTES • 12" x 9" (30CM x 23CM)

Conclusion—What Is Important to You?

In each painting, what is important to you may vary. Color may be of primary concern. Or form might be foremost. It is possible that design and composition might be your greatest concern. Atmosphere, texture or mood could possibly be your primary goal. Whatever you feel is of prime importance, other areas will also play a role in accomplishing a successful study or painting.

When approaching a study, as opposed to a more formal finished painting, it is extremely important to determine what it is that you wish to achieve. It is not enough to just copy what you see. You must first decide what it is you wish to convey about the subject. Then, as you paint, do not lose that focus. Understand that painting is a step-by-step process; that is to say, your study should build toward your desired result. Be in charge, don't let the subject take control.

Recreational Studies

This afternoon study was done about five miles from my home. The strong design created by the light and shadow pattern attracted me. With large simplified darks, this piece came together quickly, eventually focusing down to small more refined detail.

THE WHITE TRUCK • OIL • 60 MINUTES • 14" x 11" (36CM x 28CM)

CHAPTER 11

Style

Often people confuse style with technique. Technique usually refers to medium and process. Style is more about how you think. Style develops over time; a desire to work with great contrast or color is arrived at through experience. For example, Monet, Picasso and O'Keeffe all worked in oil. It was their vision and ideas that differentiated them from one another. Klimt and Vulliard were more painters of pattern, while Sargent and Rembrandt were more attracted by light and shadow.

One's basic style is an accumulation of personal taste, abilities and painting experiences. This will continue to develop and change. This keeps an artist excited and continuing to work towards an illusive goal. It may be said that you don't find a style, but it finds you.

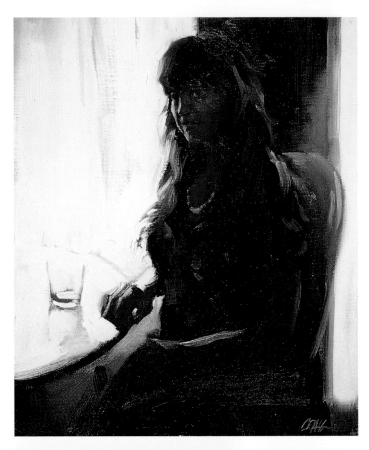

Design and Mood
The style here is very *design and mood* oriented. The light creates the shapes that define the subject. Modeling form and color play a very minor role here.

THE LOOK • OIL •
45 MINUTES • 14" x
11" (36CM X 28CM)

Mood, Movement, Color and Lighting
This is an example of attempting a style that I am somewhat unfamiliar with. It is necessary to visualize the look I am after. This is about mood, movement, color and lighting. Movement and lighting determine the somewhat loose abstracted quality.

DANCE MOVEMENTS •
OIL • 50 MINUTES •
14" x 11" (36CM X
28CM)

Color and Form
This study is very high key and oriented on form. Color is also a stylistic factor. Design and mood do not really come into play here.

THE BACK • OIL • 40 MINUTES • 16" x 12"
(41CM X 30CM)

Longer Studies

Limiting yourself to no more than an hour on a study will force a strong commitment to your brushwork and editing. It is possible to carry a study to a more complete statement. It may approach a more finished quality by putting in an additional 30 to 60 minutes. In fact, for some painters, this may be the finished look they are after.

Remember that a study is more about intent than time frame. If you are only exercising or exploring, and not necessarily attempting to finish a piece to a refined state, then it is a study by intent. However it is possible that a study itself may in actuality achieve a finish quality. This is even more possible in studies of a longer duration.

120-Minute Study

This study began with a quick compositional sketch, on a toned canvas, to capture the placement and proportional relationships of the barn to tree shapes. I developed it with nos. 10 and 12 brushes beginning with the background sky, clouds and mountains, which are all close in value. The dark shapes of the trees came next, paying close attention to the edges. The barn was laid in with a no. 10 bristle flat focusing on the roof, and the light and shadow of the barn structure. The small simple, darker shapes of the foreground were next. After dealing with the large loose foreground in simple drier strokes, darker and lighter details were finally applied to the trees and barn. The balloon was added afterward in lighter values to keep it in the distance.

FOUNTAINGROVE ROUND BARN • OIL • 120 MINUTES • 16" x 20" (41CM x 51CM) • COLLECTION OF MR. AND MRS. M. JEYE

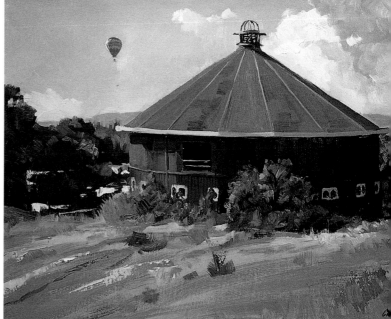

90-Minute Study

The proportional sketch for a portrait needs to be relatively accurate; therefore, it will take a little longer (approximately 10 minutes). The light comes from above and slightly to the left. Understanding this is important in the structural development. Darker and lighter structural accents are added as refinement after the form and basic likeness are already established. My older son posed for me.

BRENDAN'S HAT • OIL • 90 MINUTES • 16" x 12" (41CM x 30CM)

When Is It Finished?

"How do I know when the painting is finished?" is a somewhat difficult question to answer. A painter's experience in developing paintings helps to resolve the question of when it is finished. Knowing what is the desired result also helps.

To assist with this quandary, you may wish to ask yourself a series of questions:

1. What is my first impression of the painting?
2. Is there anything that truly bothers me?
3. Do I like my brushstrokes and application?
4. Does it feel as if it needs something? What?
5. Should something be eliminated or simplified?
6. How is the overall readability?
7. Does it have impact (from a distance)?
8. Does it have a payoff (aesthetics from up close)?

Finally, wait a few days and look at the painting again.

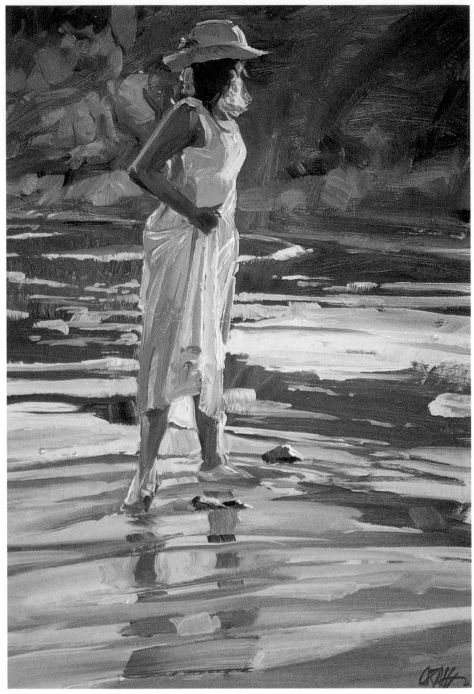

What Makes the Painting Complete?
The mood and lighting allow for an involvement in color play in the lighter subjects. Keeping this as a primary goal leads to an understated background. A bold, powerful application of paint establishes the ground plane. All this sets up the study for color variations on the white dress and the glow of the striking sunlight. Although understated, this feels like a complete and satisfying painting.

CALIFORNIA DREAMIN' • OIL • 120 MINUTES • 16" x 12" (41CM x 30CM)

A Study vs. Finished Painting

Occasionally, a figurative pose may strike you and capturing it is the most important thing for you to do. Upon further evaluation it is obvious that this is a gestural study that needs to be completed as a more developed painting.

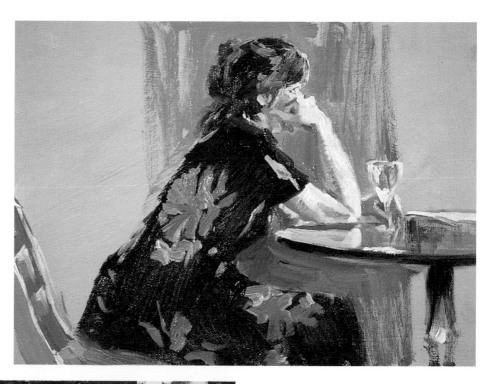

Great Figure, No Background

This was a random pose that my wife took, and I was intrigued by the mystery of not completely revealing her face. Also the bold graphic pattern of her dress was appealing. However, this is a figure in search of an environment.

AT THE TABLE • OIL • 25 MINUTES • 9" x 12" (23CM x 30CM)

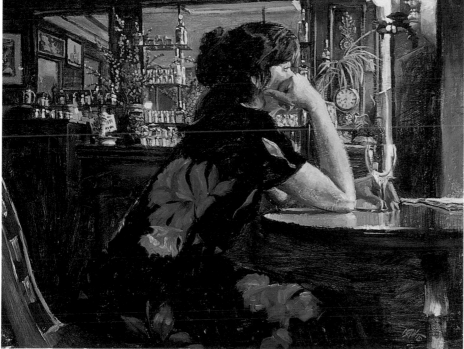

Adding in the Background

Determined to use the pose from *At the Table*, I washed in the silhouette form on a gray-green toned panel. I then referenced my photos of a European trip; the pose suggested Europe to me. Finding a shot of a Parisian bistro interior, I sketched the pose in the setting, attempting to keep the perspective consistent. The entire background environment was completely blocked in before beginning the figure. Refinements and lighting details were developed at the final stage. This painting was done over a two-day period.

BISTRO DE PARIS • OIL • 18" x 24" (46CM x 61CM) • PRIVATE COLLECTION

Keeping the Passion Alive

Passion is absolutely a premier factor for any artist. It is possible for this to wane from time to time. Burn out, boredom, or a general lack of inspiration may set in. Complacency for a painter is a tremendously negative factor, inhibiting growth.

Quick studies are a wonderful way to keep passion alive in painting. The sheer enjoyment of painting can be revitalized. Rediscovering the sensuality of moving paint around may reinvent the passion. The satisfaction of rapidly capturing a subject may be the incentive. In any case, the small, abbreviated quick study may be just the necessary ingredient. A few small quickies here are done just for the joy of painting. Messing around with paint is just a lot of fun.

A larger more refined piece may also help keep passion in one's painting. Painting an interesting model from life may be a wonderful stimulant for rediscovering enthusiasm in painting. Painting must truly be a passionate pursuit. It is a joy, a treasure and lifelong journey for all who partake to thoroughly enjoy.

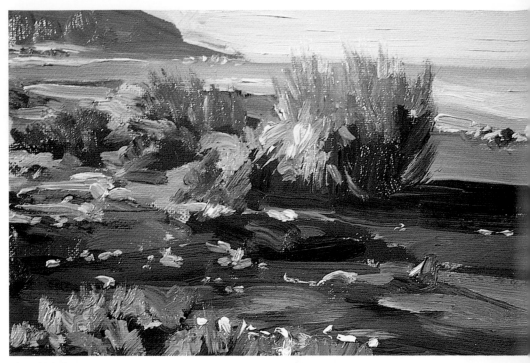

Direct Painting
No sketching on the quickies, just blocking in large shapes. Refinements come in the form of breaking down the larger masses according to the light effects.

MARIN MORNING • OIL • 20 MINUTES • 6" x 9" (15CM x 23CM)

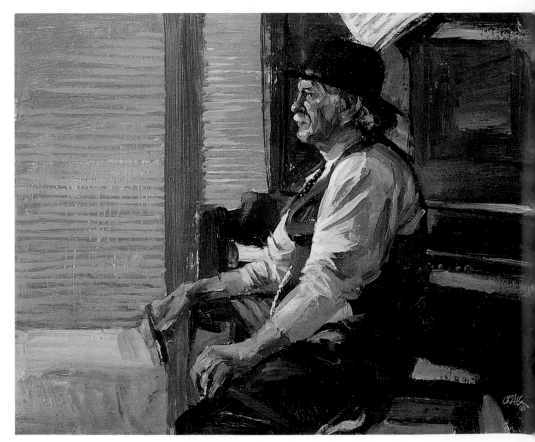

Focus on the Model...A Little Longer
The model here was definitely interesting. The pose was stimulating and the subtle setting completed the picture. It was a labor of love.

PIANO MAN • OIL • 120 MINUTES • 16" x 20" (41CM x 51CM) • PRIVATE COLLECTION

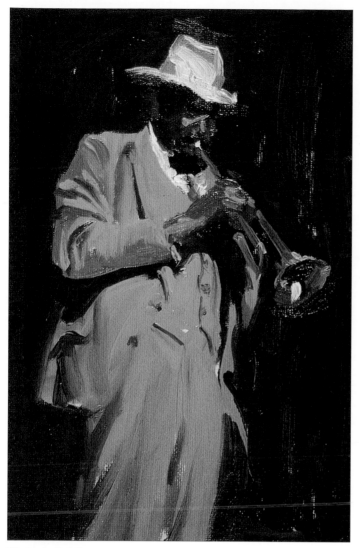

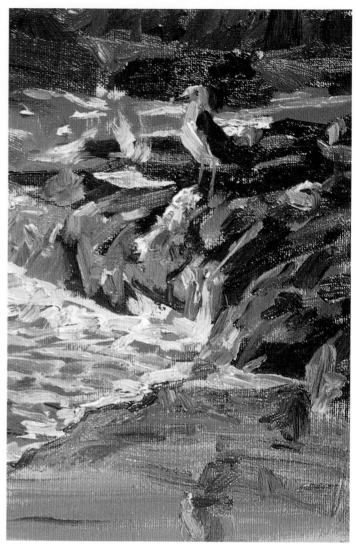

Eliminate Detail
Simplified light and shadow define this figure. No actual detail is developed. Strong powerful shapes and a few linear refinements create the essence of the subject.

TRUMPETEER • OIL • 20 MINUTES • 9" x 6" (23CM x 15CM)

Vivid Colors and Strong Contrasts
During late sunset, the warm light changes quickly. The whites are all tinged by a warm peach-colored glow. Big chunky strokes comprise this piece with vivid coloration and strong value contrast.

SUNSET SEAGULL • OIL • 20 MINUTES • 9" x 6" (23CM x 15CM)

Index

Make the most of the time you spend painting— these exciting titles will show you how!

This book shows you how to develop the skills you need to express yourself no matter what unusual approach your creations call for! Experiment with and explore your favorite medium through dozens of step-by-step mini demos. No matter what your level of skill, Celebrate Your Creative Self can help make your artistic dreams a reality!

ISBN 1-58180-102-5, HARDCOVER, 144 PAGES, #31790-K

Create your own artist's journal and capture those fleeting moments of inspiration and beauty! Erin O'Toole's friendly, fun-to-read advice makes getting started easy. You'll learn how to observe and record what you see, compose images that come alive with color and movement, and make a travel kit for creating art anywhere, at any time.

ISBN 1-58180-170-X, HARDCOVER, 128 PAGES, #31921-K

Whether your subject is Caucasian, Asian, Black or Hispanic, this book provides practical guidelines for depicting realistic skin tones in your portraiture. Lessons and demonstrations in oils, pastels and watercolors teach you how to mix colors, work with light and shadow and edit your compositions for glowing portraits you'll be proud of.

ISBN 1-58180-163-7 (U.S.), 0715312669 (UK), HARDCOVER, 128 PAGES, #31913-K

Create nature paintings of extraordinary intimacy and mystery! These step-by-step guidelines work for whatever medium you use. Whether painting scales, feathers, sand or fog, it's all the information you need to render the trickiest of details with skill and style. A full-size demo, combining animals with their environment, focuses all of these lessons into one dynamic painting.

ISBN 1-58180-050-9, HARDCOVER, 144 PAGES, #31842-K